D1370097

WEDDING PHOTOJOURNALISM
Techniques and Images in Black & White

Andy Marcus

AMHERST MEDIA, INC. ■ BUFFALO, NY

Dedication

I would like to dedicate this book to my father, Fred Marcus, who has given me guidance and knowledge, support and love for so many years.

Thank you for everything. Your strength of character and your generosity of spirit has always, and will always, inspire me.

Copyright ©1999 by Andy Marcus.
All photographs by the author.
All rights reserved.

Published by:
Amherst Media, Inc.
P.O. Box 586
Buffalo, N.Y. 14226
Fax: 716-874-4508

Publisher: Craig Alesse
Senior Editor/Project Manager: Michelle Perkins
Assistant Editor: Matthew A. Kreib
Scanning Technician: John Gryta

ISBN: 1-58428-011-5
Library of Congress Card Catalog Number: 99-72173
Printed in the United States of America.
10 9 8 7 6 5 4 3 2 1

Notice of Disclaimer: The information contained in this book is based on the author's experience and opinions. The author and publisher will not be held liable for the use or misuse of the information in this book.

Table of Contents

Introduction4
Before the Wedding7
 Bridal Dressing Room8
 Multiple Images11
 Staying in the Background13
 Unique Perspective14
 The Little Things17
 Photographing the Men18
 Portrait Photography21
The Ceremony22
 Outdoor Weddings23
 Photographing the Ceremony25
 Lens Selection26
 Emotional Moments28
 Getting Prepared and Positioned . . .31
 Getting the Details33
Portraits of the Bride34
 High-Energy Subjects35
 A Favorite Image36
 Film Usage39
 Covering Large Weddings40
 Creative Ideas with Film42
 To Pose or Not to Pose45
 Black & White for Details47
 Diagonals and Composition49
 Details Equal Sales50
 Camera Tilt52
 Keep Your Eyes Open54
Children at the Wedding56
 Anticipating Action57
 Right Place, Right Time58
 A Spontaneous Moment61
 Always on the Look Out63
 Details, Details, Details64

The Flower Girls and the Bride66
A Little Shy69
Shooting a Sequence71
Getting Great Expressions72
Taking to the Streets73
 Portraits in the City75
 Opening and Closing Shots77
 Pricing .79
 Get Outside and Have Fun80
 Kisses .82
 Creative Location Photography84
Portraits of the Couple86
 Be Prepared87
 Finding a Unique Viewpoint88
 Telling a Story91
 The Groom92
 Personalities94
 35mm Only96
 Setting up a Shot99
 Printing Options100
 End of the Ceremony102
 Instant Action105
 Working Alone106
The Reception108
 Everything is Fair Game109
 Emotional Impact110
 Sharpness112
 Too Much to Choose From115
 Switching Gears117
 Photojournalism vs. Traditional
 Photography119
 Closing Thoughts120
Index .122

Introduction

□ Wedding Photojournalism

The day a young woman gets married is probably one of the most important in her life. The most challenging aspect of photographing the wedding is capturing the joy and emotion she is experiencing. Doing this effectively requires anticipating the special moments of a wedding, and being ready before they happen.

Wedding photojournalism, as opposed to traditional wedding photography, focuses on capturing the little things that the traditional wedding photographer sees out of the corner of his/her eye as he/she poses portraits and captures the big events during a wedding. These could be the emotions on people's faces, and even details like the lace on a bride's dress.

Wedding photojournalism is certainly not for everyone. It caters to a bride that "gets it" – one who understands its limitations and advantages. It appeals to the romantic side of brides. Brides who want to see a more "behind the scenes" look at their wedding will appreciate the unique images that this style of photography can offer. As a photographer, I appreciate how it gives me a new way to look at weddings and to be even more creative.

Rather than promoting photojournalism as a replacement for traditional wedding photography, I feel that the photojournalistic style works best in concert with traditional photography to give brides the most complete coverage of their special day. Traditional photography is still important – maybe even more important in the big picture. After all, parents still like to have the family portraits, and brides, when all is said and done, still like the traditional coverage of their wedding. An exclusively photojournalistic approach to wedding photography is possible, but one has to be careful when selling this. Brides must understand what they will be getting, but more importantly what they will not be getting. Again, I usually try to sell black & white photojournalism as an addition to our traditional coverage of a couple's wedding, thereby selling two albums instead of one.

To shoot photojournalistic wedding images successfully requires some special skills. First, you must keep an open mind, and an eye out for the unusual. Second, you need to have the technical skills to be able to shoot without thinking about equipment, exposure or lighting. Success depends on these skills coming easily and naturally to you. Finally, to capture those unique

Wedding photojournalism focuses on capturing the little things ..."

moments – the right expression, the right composition, the right light – you must be totally aware of everything that is going on around you at all times.

☐ Background

My interest in photography began when I was about ten years old. My father, Fred Marcus, a professional photographer for over sixty years, gave me a camera as a birthday gift and off I went. Of course, having your father as one of the most well respected photographers in New York did not hurt either. He was always there to help me, advise me and correct my mistakes.

My training was anything but formal. You could say it was on the job training. When I was thirteen, my father offered me a job as a lighting assistant at weddings he was photographing. I would go out with him on Saturday nights and we would shoot weddings – mind you, this was with a 4x5 Graflex camera, shooting black & white film. We would get home around 2 a.m., then sit in a dark closet in our apartment and reload film holders for the next day's shoot. I did learn how to pose and light people to their best advantage. Most of all I learned how to deal with all the different personalities at a wedding, winning them over, and making that work for me.

Since then, my work has been published in every major bridal magazine and most photographic magazines. My work has also been published in *People* magazine and *US* magazine among many others. I received my first Court of Honor in 1972 from the New York State Professional Photographers. I had not entered many print competitions until recently when I found I was close to receiving my Master of Photography degree from the Professional Photographers of America. Then I entered four prints, receiving blue ribbons and two Loan Collection awards. My first gallery exhibition was held at the Leica Gallery in Manhattan and was strictly black & white photojournalism.

☐ Fred Marcus Photography

Fred Marcus Photography has been around since 1941 when my father immigrated to the United States from Germany by way of Cuba. He spent two years waiting for a visa to come to America, and in that time took photographs on the beaches of Cuba of other immigrating families. They liked his work and he followed them to New York where they remembered him when family events called for a professional photographer.

"My training was anything but formal."

When I started in this business full time in 1971, I came in watching what was going on in our studio, the type of clientele that we were dealing with, and little by little got a feeling for the business from the bottom up. Our studio, at that time, was located in the basement of our building – or the "lower lobby" as we used to refer to it. I felt that the clientele that we were attracting was becoming more and more upscale, so I discussed with my dad the possibility of taking more space in the building – and we moved our sales operation upstairs to the main level! We called in space planners and designed a very contemporary, refined look for this sales area.

The new sales area meant these prosperous customers now had an attractive place to come to; one that we could be proud of. We began to do a lot of celebrity weddings for people such a Mary Tyler Moore, Art Garfunkel, Donald Trump, Billy Baldwin and Eddie Murphy, just to name a few of our notable clients whose names you would recognize.

> "We began to do a lot of celebrity weddings..."

Today I am the President of the company and, while my dad (at 88) still comes in several times a week, most of the daily functions of the studio are handled by me. We have eighteen full time employees and a total of about fifty people altogether who work for our studio. We do approximately 450-500 parties each year, the majority of which would be called extremely upscale.

☐ The Future
I started out with, and still do, traditional wedding photography. Photojournalism has been an outgrowth of that. Creating these images that show the emotion and fun of the day has given me a lot of satisfaction and kept me fresh and excited about the work that I do. Yet, as much as I like spending time with people on one of the happiest days of their lives, my favorite part of my job is not the actual shooting but watching a bride's face as she goes through the photographs after the wedding. That is what makes all the hard work worthwhile.

I plan to keep expanding my expertise in photojournalism. Probably, in the near future, I will start to get into the digital area of wedding photography. I have never stopped learning. Once a photographer thinks he has learned all he can, or thinks he knows all there is to know, he may as well put down his camera and go into another business.

Before the Wedding

Bridal Dressing Room

☐ Preparing for the Wedding

I have been photographing weddings for a long time – I think you could put me into any situation and I would bring you back wedding photographs that you would be proud to show. I normally discuss details of the wedding with our brides a week or two before the wedding. I never speak to my brides the week of their wedding unless they need to speak to me. I just think that they have a lot more important things on their minds, and I don't want to interfere with them in any way. When we talk, we discuss all aspects of the day – what they are expecting, and what we can or cannot do. I rarely visit a new location prior to the wedding. I find that it really serves no purpose because the venue will be decorated and furniture will be moved around and what I probably would have liked to use as a background for portraits, the florist or caterer will have decided to use as a background for a food display or floral arrangement. I usually arrive at the wedding about 45 minutes before I am to begin shooting. I scout out a good area that will afford a good backdrop for my family photographs then I have my assistant set up my lighting, and I am off to say hello to the bride – camera in hand.

☐ The Bridal Dressing Room

I explain to my brides before the wedding what I intend to do. Whatever limitations they put on me are up to them and, of course, are respected. I like to spend time in the bride's dressing room before the wedding. I like to get the look in the bride's eyes as she sees herself being transformed – the hair, the makeup, the jewelry, etc. Some of my best images come out of the hour or so I spend with the bride. I don't move around a lot when I work, have very little conversation with the people around me. I stay out of the way of everybody, and yet I take everything in. In this particular shot, I had just walked into the bride's hotel suite and saw this image. Nothing was set up, which is generally the case when I am shooting wedding photojournalism. That would defeat my purpose. The light on the gown was beautiful, and I knew that the subjects would be in silhouette. Showing details is a very important part of my photography, and using the window light crossing the dress enhanced all the details of the gown. The shot was done on TMAX 3200, metering off the window and then opening the lens two stops to pick up the detail in the gown.

"I like to get the look in the bride's eyes as she sees herself being transformed ..."

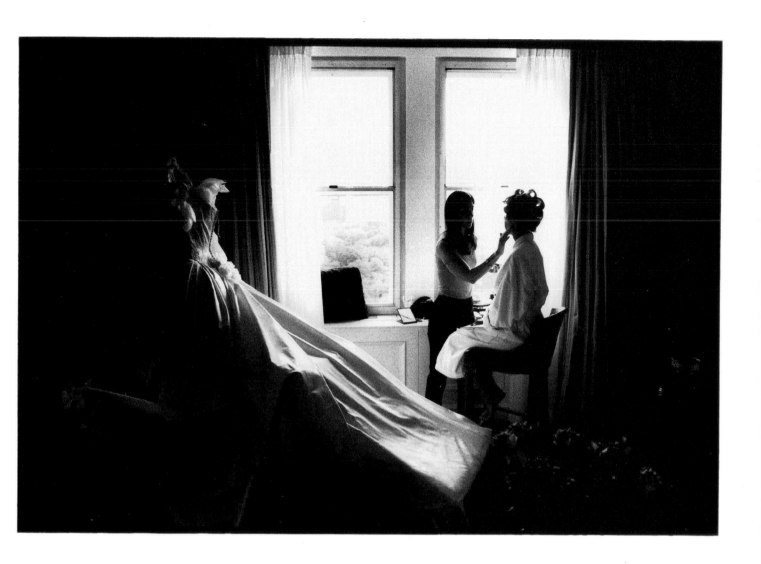

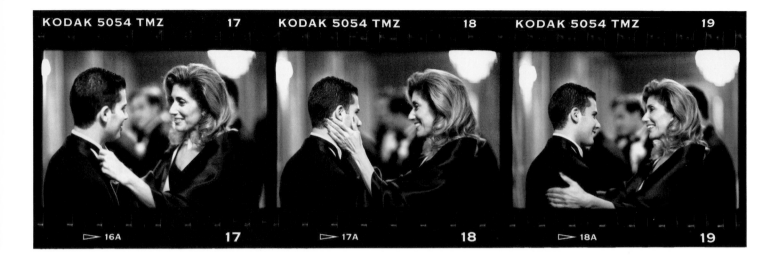

Multiple Images

☐ The Bridal Dressing Room

This is a photograph of the groom and his mother. The groom's father had been a very well known commercial photographer whose work I had admired for many years. He had passed away several years before and I wanted to do something special for his family. I saw this moment between mother and son happening, and raised the camera to my eye. I immediately took the first image of the mother adjusting her son's tie. Then I waited, and as they talked, she touched his cheek – click – second image. Finally, they smiled at each other – third image. I look for situations like this that could produce multiple images and think of them for future use in the album as panoramic photographs spread across two pages. I print these images, most times, with the sprocket holes and film info showing, just to give the shots a bit of a different look.

☐ Photography

This image was shot with the 85mm, f-1.2 Canon lens on TMAX 3200 film.

☐ Lighting

The lighting was ambient, coming from overhead. Of course, the beauty is it really doesn't matter what color the light it is, because we are dealing with black & white images.

> "I look for situations like this that could produce multiple images ..."

light from
wall-mounted sconces

subjects in hallway

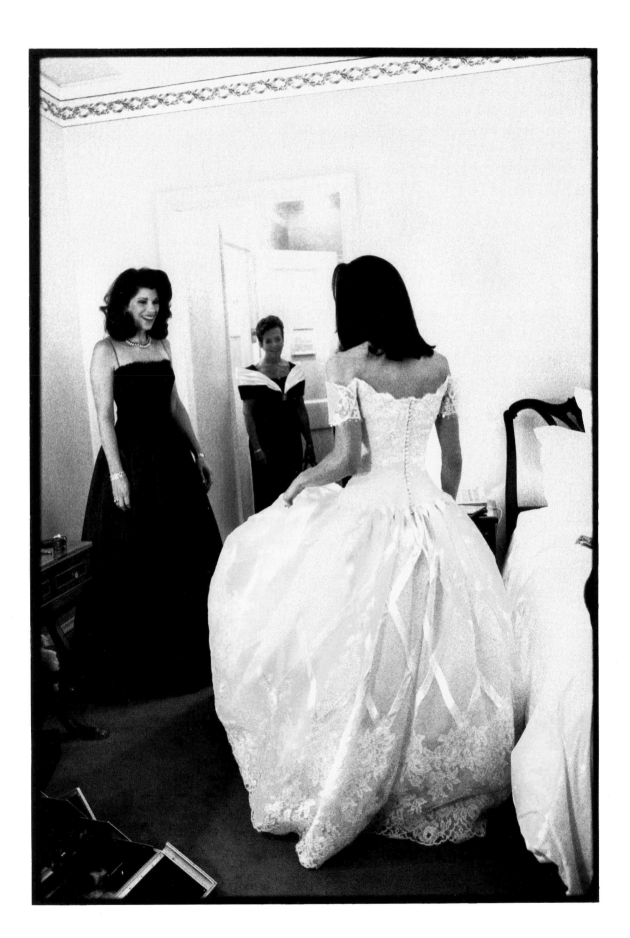

Staying in the Background

☐ Staying in the Background

This is a good example of what I mean by staying in the background and shooting. Don't get involved, just let things happen. This bride was finished getting dressed and about to leave to take her formal wedding portraits. Her mom walked into the room and this was her reaction to seeing her little girl as a bride.

☐ Lighting

The shot was made with available light coming from a window behind and to the left of the camera.

☐ Composition and Photography

I compose my shots so as not to have to crop them, filling the frame with what I want and not leaving any unnecessary space. For this shot, I used the Canon 28-70mm f-2.8 lens, with TMAX 3200 film.

I spend about 45 minutes to an hour prior to our portrait session taking pictures of both the bride and groom (when possible) getting ready. I do no traditional photography during that time. This is because I have always felt that, when a bride opens a wedding album done in the traditional manner, she will not want to see herself in the first few pictures in a bathrobe and curlers. What she wants is to see in the traditional album is the finished product – herself as a bride.

"Her mom walked into the room and this was her reaction ..."

lamp on
night stand

window
light

☐ Unique Perspective

On the opposite page are two very similar images. When I go into the room where the bride is getting ready, I look for unusual angles and different perspectives. Traditional photography is sort of straight-forward, "looking in the camera" kind of stuff, for the most part. I feel that, with wedding photojournalism, we take a different perspective in order to look at the wedding in a unique way.

☐ Setting

In the top image, the bride was applying makeup and I saw her holding up the compact and looking at herself. I saw both eyes appear in the compact's mirror and, using the Canon 85mm f-1.2 lens, I shot a couple of frames. The bride was not aware I was shooting. In the bottom image, the bride was a personal friend of mine and we were talking as she applied her eye makeup. As she talked, she looked up at me in the mirror and I grabbed the shot.

☐ Depth of Field

With shots like this, I work with a large aperture (around f-4.0). This insures that I am able to keep the focus just on the face and eyes.

"...take a different perspective in order to look at the wedding in a unique way."

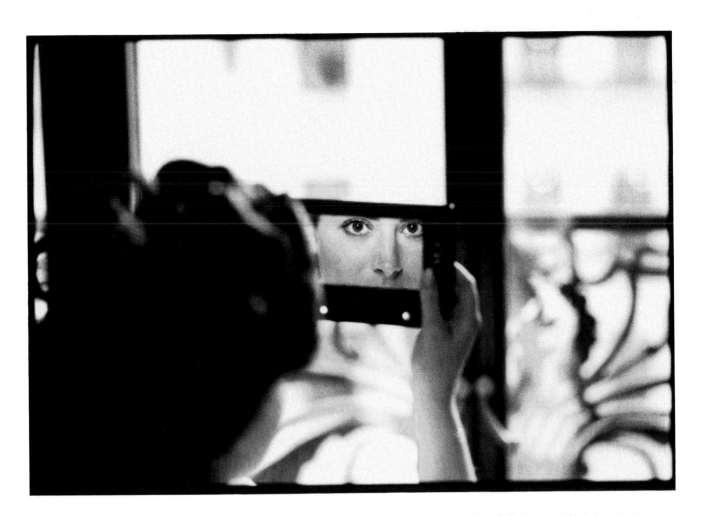

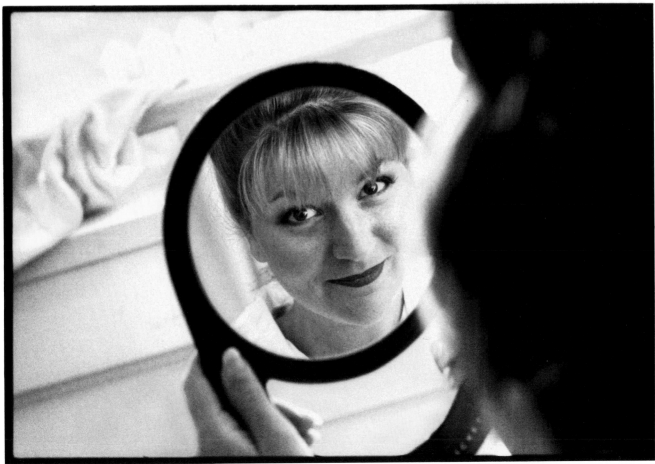

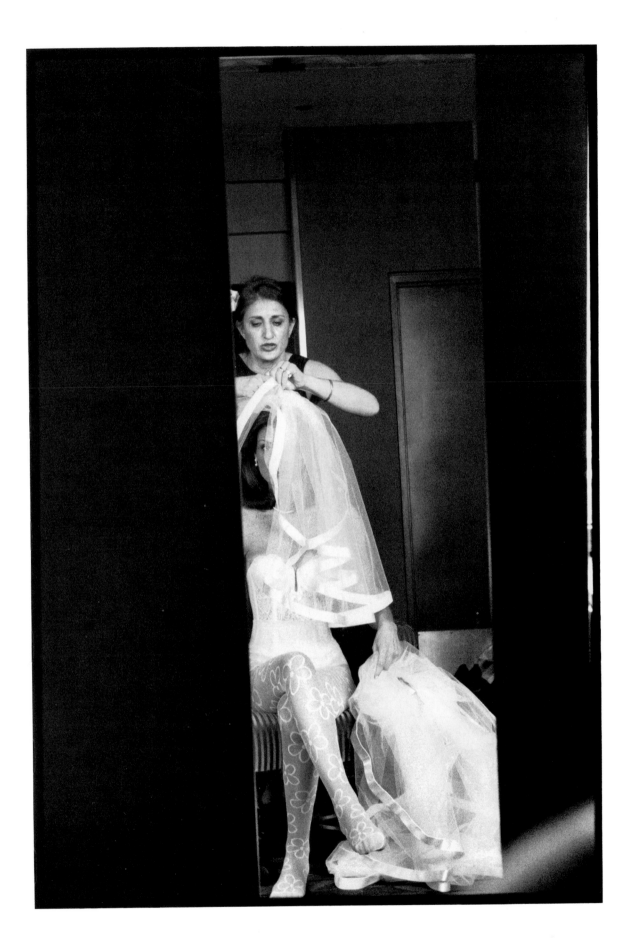

The Little Things

☐ The Little Things

When I shoot black & white photojournalism, I look to shoot the behind-the-scenes action. Everyone will not look perfect, so I save that look for my traditional work. The "day" I photograph is the "day" most people never see, and never remember. It encompasses the little things that sometimes are forgotten or go unnoticed. Before I started shooting wedding photojournalism I would see these moments, but was unable to record them. Now I have the ability to capture these moments forever, and keep these wedding memories alive.

☐ Setting

I love this image. It was part of a series of images for this bride who, when I knocked on her dressing room door, answered it herself dressed in this fabulous lingerie, her headpiece and veil. After catching my breath and composing myself, I walked into the room and sat down and waited. Shooting as I waited, I saw her sitting with the headpiece secured to her head, the veil over the front of her face and only one eye showing – wow! I started shooting while tilting the camera slightly to get a little feeling of motion in the photograph. The image also has a bit of a voyeuristic look to it.

☐ Lighting

The lighting was strictly from high hats in the room – there were no windows.

"The day I photograph is the day most people never see, and never remember."

Photographing the Men

In most cases, the women are much more fun to photograph than the men at a wedding. The groomsmen tend to sit around a room watching a football game or a golf match. Additionally, they are all dressed the same, so there is really nothing much to be done as far as details in clothing. I have nothing against photographing the groom and his friends; I do it, but it's just not very interesting. Guys simply don't fuss and prepare for this day the way women do.

Setting and Lighting

This image was taken in the church just before the ceremony was to begin. It shows the groom adjusting his son's tie and jacket. It was a private moment and I captured it with the Canon 85mm f-1.2 lens, using only available light coming through the stained glass window.

Quantity vs. Quality

When shooting pre-ceremony (or "getting ready" photographs), I rarely shoot more than a couple of rolls. I try to make each shot count and have always felt that quantity is does not necessarily translate into quality.

"Guys simply don't fuss and prepare for this day as women do."

window
light

white chuch walls
act as reflectors

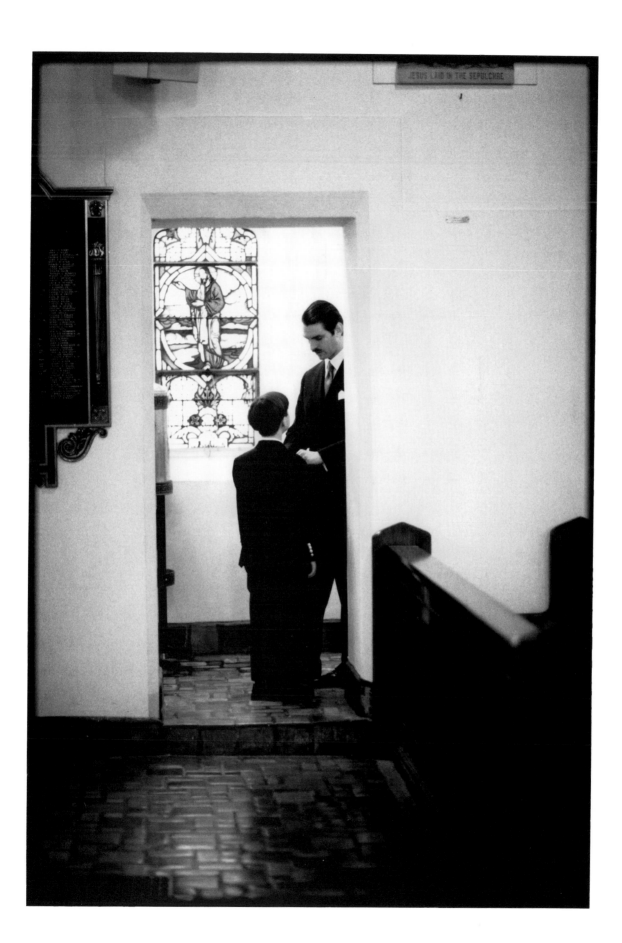

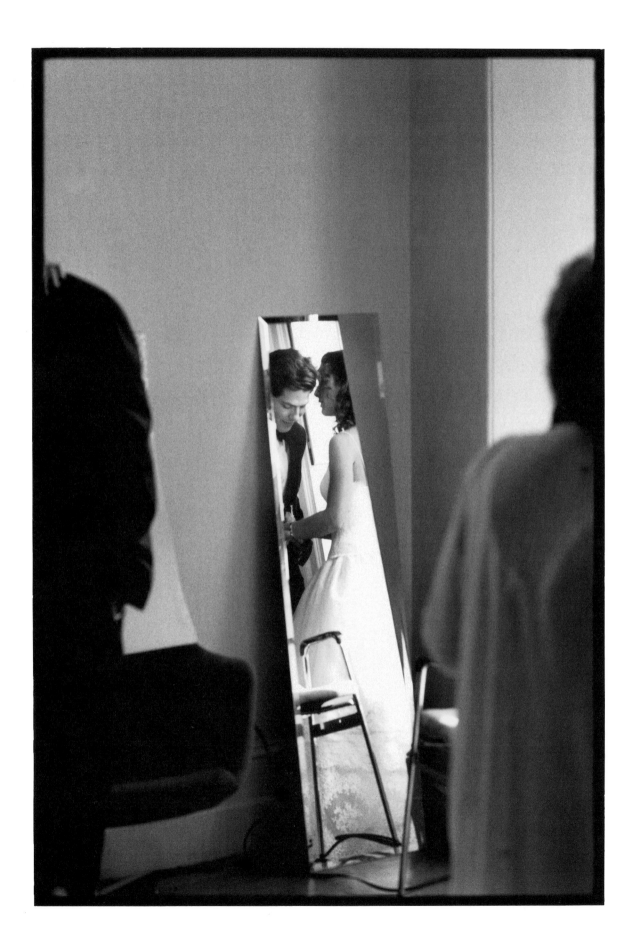

Portrait Photography

☐ Photography and Lighting

This image was shot using a Canon EOS 1n with a 70-200mm lens. Available light was used to record this image on TMAX 400CN film, a wonderful film that can be processed in color chemistry.

☐ Portrait Photography Techniques

I feel that good portrait photography techniques ultimately help you become a better photographer in general. When you really look at a person, you tend to find the best way in which to photograph them.

☐ Being Unobtrusive

Doing this type of photography requires that you be unobtrusive, that you blend into the scene and become the proverbial "fly on the wall." I tend to use long telephoto lenses and fast films which allow me to work at a distance without being noticed. I have seen photographers that practice this type of photography use flash and a motor drive, thinking that they will capture the moment. Actually, what they do is lose the moment. As soon as a flash goes off, people become aware that they are being photographed and the natural becomes contrived. This is exactly what I don't want.

☐ Wedding Albums

I am trying to sell people two wedding albums – one of traditional posed coverage, and another with images like the ones in this book. This second album shows the other side of the wedding – filled with photographs that depict the emotion and excitement of the day.

☐ Shooting in B&W

I shoot all my photojournalistic 35mm images with only black & white film. The goal is to create an album of just black & white, not to mix color and black & white. I save the color images for my Hasselblad and the traditional wedding album. Black & white, for me, has a very special look. I feel it conveys the essence of a person or scene without allowing the viewer to get distracted by all the colors. Black & white allows you focus on people and personalities. I like the way it contrasts with the color coverage that we give our brides.

> "... good portrait techniques ultimately help you become a better photographer in general."

The Ceremony

Outdoor Weddings

☐ Setting

This photograph was taken during an outdoor wedding ceremony, as the bride and groom were exchanging rings.

☐ Lens Flare

The lighting for the image came from a very late-day setting sun. I would have taken this photograph from the rear of the aisle, except that it would have resulted in a huge amount of flare from the sun. Rather than give up on the shot, I decided instead to shoot from an angle, allowing me to get this important moment during the ceremony.

☐ Photography

The film used for this portrait was Kodak TMAX 400 film, with a 70-200mm f-2.8 lens.

"Rather than give up on the shot, I decided instead to shoot from an angle..."

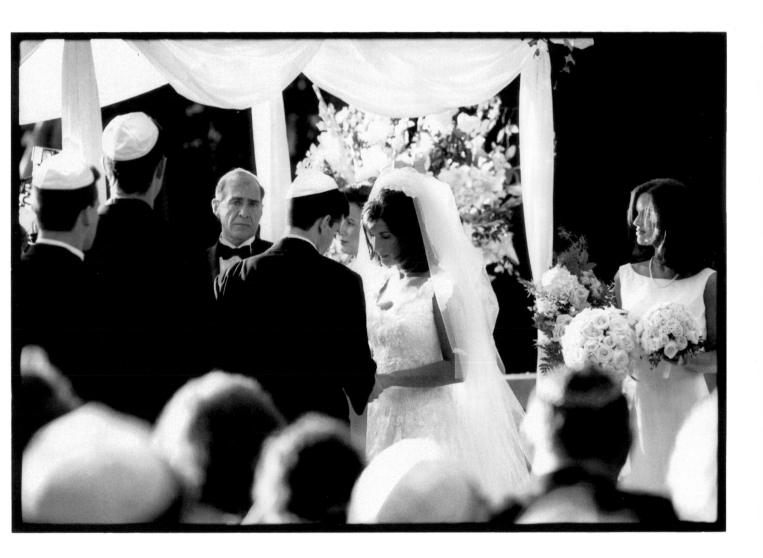

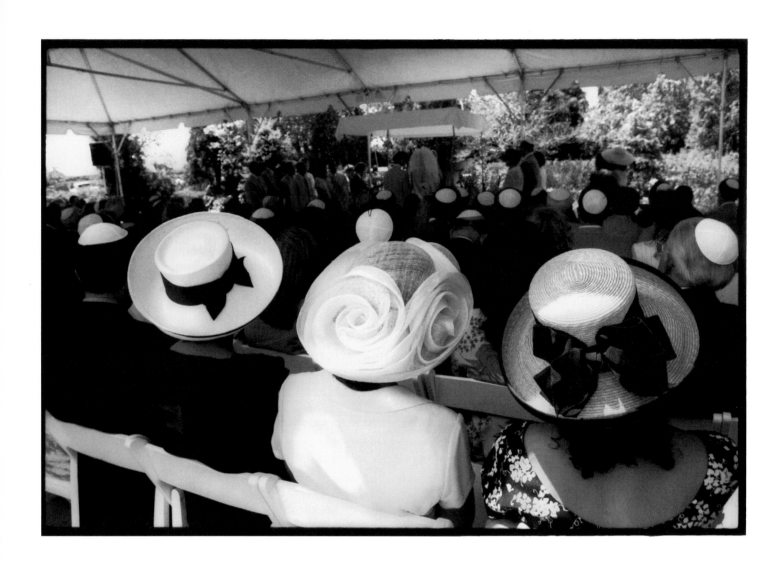

Photographing the Ceremony

☐ Photographing the Ceremony

Photographing ceremonies is the one part of wedding photography that a photographer needs to be the most conscious of. Everyone is watching you. If you are unobtrusive, people will notice. This is good. If you look like you are nervous or you move around too much, people will notice. This is bad. The idea is to be as low key as possible and yet still be able to capture the moment.

☐ Variations in the Ceremonies

Every faith has different customs. One must become knowledgeable in these customs and be ready to photograph them when they take place. That said, photographing ceremonies of different faiths is really not a problem, but it is always important to be aware of the particular differences in each ceremony.

☐ Lighting

This image was taken at a large wedding that I was photographing in Southampton, NY. It was an afternoon wedding and the weather was beautiful – almost too beautiful. For outdoor photography, I prefer to work when the sky is ever so slightly overcast, so that shadows are not too strong. However, the plus side of working on a bright day is that I can use a slower film such as Kodak TMAX 400.

☐ Capturing the Moment

This image just appeared in front of me. The three women were taking their seats for the ceremony in the back row, and their hats caught my eyes. They settled in, and the light just hit their hats in such a wonderful way I was afraid that I might lose the moment, so I shot a couple of exposures right away, then went on to get ready for the ceremony.

"If you are unobtrusive people will notice. This is good."

Lens Selection

☐ Lens Selection

I use different lenses depending on the situation I am going into. Zoom lenses, as opposed to ones of fixed focal length lenses, afford the ability to work at different distances without making lens changes. If I am working in a tight situation I might choose the Canon 17-35mm f-2.8 lens. If I am working in a large open area, I would probably shoot with the 70-200mm lens. In between, I use the 28-70mm lens. These three lenses probably cover most situations that you would encounter at a wedding.

Here, the couple requested that no photographs be taken during the ceremony, and I honored that request to a point. I thought that the story would not be complete if it did not include a couple of images of the ceremony, so I took this from almost 300 feet away with the 70-200mm lens set at 200mm.

☐ Setting

This image was taken in Easthampton, on a fabulous estate. This was the same home that President Clinton visited when he came to the Hamptons in 1998. It was the owner's wedding, and the ceremony was held overlooking the ocean. It was very stark, and very simple.

☐ Lighting

The lighting was late afternoon light, slightly overcast. I chose a low angle to silhouette the bride and groom against the sky. I exposed to give some detail in the foreground without letting the sky take over the metering system, which would have resulted in a completely dark foreground. The image was shot on TMAX 400 film.

☐ Working Outdoors

Working outdoors is much easier than working indoors. Shutter speeds are faster, so you don't have to worry about camera shake. You can also move a lot more easily and not be encumbered by walls, etc. Films with a slower ISO than my customary 3200 should be used when shooting outdoors. Your final images will have a much less grainy look to them.

"These three lenses cover most situations you would encounter at a wedding."

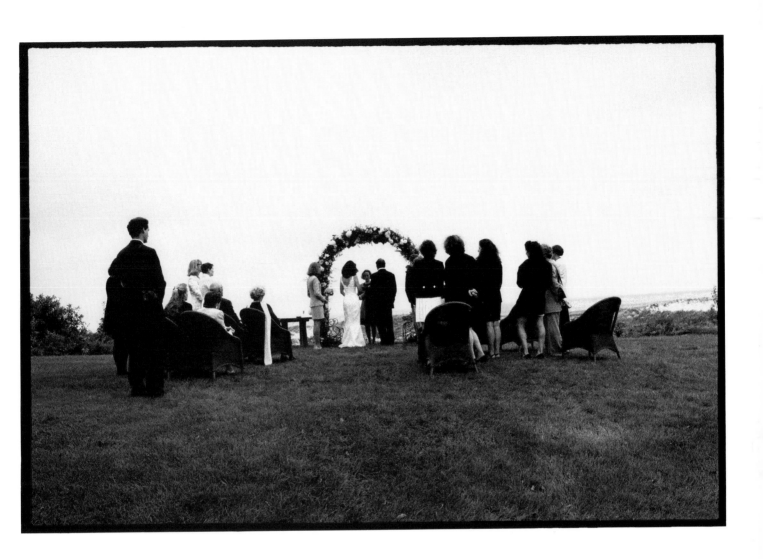

Emotional Moments

☐ Setting

This image was taken in the "bridal" room where the bride was getting dressed. This room was all white and rather large as far as dressing rooms go. The bride and her dad were talking, and things got a little emotional. She began to cry as some brides do before their wedding – in this case it was probably just nerves. I saw this happening and had to make a quick decision. Do I or do I not take this photograph? I decided that this was a special moment and that, as far as I could see, it did not involve anything bad. However, I did not want to intrude on something so personal by coming in close with my camera and interfering.

☐ Lens Selection and Composition

I decided to use my longest telephoto lens (which was 300mm) and I moved to the furthest corner of the room. I zoomed in and composed my image. I noticed the bride's brother standing in the left corner of the frame and decided to include him in the image because of the concerned look on his face. I waited a moment, saw the dad lean in, and pushed the shutter release.

☐ Lighting

The lighting was strictly available light coming in from the windows behind the bride and her dad. I used spot metering to avoid the subjects becoming too underexposed. Tri-X 400 film was used. I just took a couple of shots and then put my camera down.

☐ Use Good Judgement

The bride never knew that the image was taken. One must use good judgment when photographing emotional moments such as these. I think that, had I walked in flashing a light and intruding, I would have sacrificed my relationship with the bride and that would have caused me problems for the rest of the wedding. Always think before you shoot. You never want to embarrass yourself or your clients.

"Do I or do I not take this photograph?"

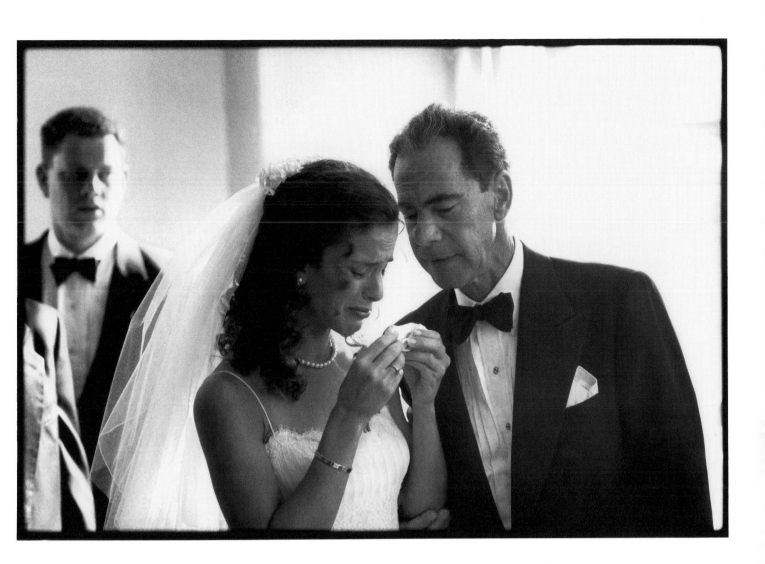

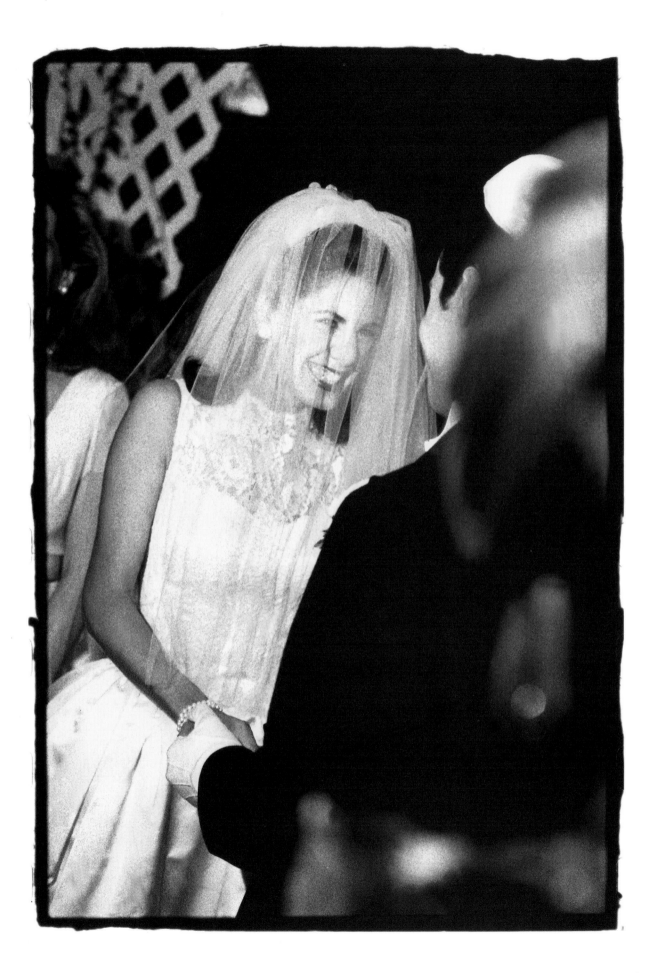

Getting Prepared and Positioned

☐ Ask About Restrictions

Photographing during the actual ceremony can be a little tricky. I always ask the officiant if he has any restrictions as to photography during the actual ceremony. Most appreciate the fact that you asked. I think most photographers don't, and this could lead to a serious problem during the ceremony. I find out what is allowed and what is not, then plan my photography accordingly.

☐ Getting in Position

This photograph was taken at a Jewish ceremony, under the chuppa, the traditional wedding canopy. After photographing the procession, I quietly walked behind the officiant and with a 70-200mm Canon f-2.8 lens. I then waited for very special moments during the ceremony. This way, camera noise is kept to a minimum. Here, the bride and groom were exchanging vows and all of a sudden the bride gave the groom this big loving smile. I was ready and caught it. The exchange of rings, drinking of wine, the kiss etc., are all important moments of the ceremony that must be captured. I prefer to shoot from behind the officiant so that I can better capture the expressions on the faces of the bride and groom.

☐ Lighting and Metering

Lighting was a combination of ambient light and light from the video coverage that was present at the moment. I usually expose using the spot meter mode on my EOS-1n. This prevents overexposure caused if the matrix metering is used. Usually there are too many dark areas (black tuxedos, darkened room), and the camera will tend to overexpose the image. The slight camera tilt adds a little excitement.

"... all of a sudden the bride gave the groom this big loving smile."

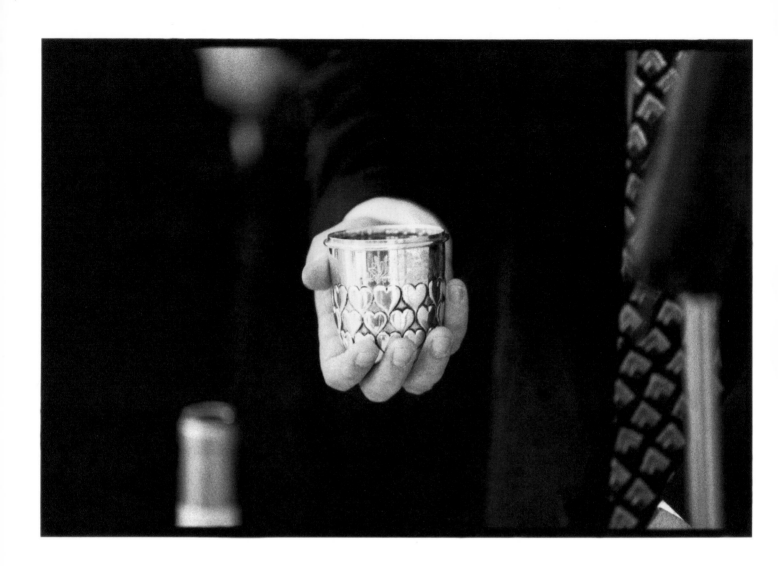

Getting the Details

..

☐ Getting the Details

Details are so important to covering a wedding in a photojournalistic manner. Zooming in and capturing a small detail may add to the telling of a full story of the day. My goal in all of this is obviously to sell photographs. That is my business. By taking photographs that are interesting and different than those taken when I photograph in a traditional manner, I am able to sell a different kind of album, one that tells a different story of the wedding day.

This photograph is a good example of how important details can be. During the ceremony, a blessing was being made over the wine and I found the cup interesting – different. I took the picture and later found that this particular cup had been used by the family for many years. Of course, it turned into one of the most important pictures for them.

☐ Photography

This image was shot using only available light on Kodak TMAX 3200 film.

☐ Two Unique Albums

When we photograph a wedding, I like to include both types of coverage – traditional and photojournalistic. I find that I am able to give my brides two different views of their weddings, and sell two different albums of the same wedding. Parents and grandparents tend to like the traditional coverage, which includes portraits of family done in a very casual manner. The bride and groom tend to like the more candid moments of the day, but still, in the end, wind up with many of the posed images as well.

"Of course, it turned into one of the most important pictures for them."

Portraits
of the Bride

High-Energy Subjects

□ A Great Subject

This bride was great for me as a photographer. She had so much energy, and it didn't take much to get it out of her. There was just a moment during the wedding when I happened to have my camera focused on her face, and she turned and let out this wonderful expression. I was ready and shot the photograph. It was unposed and shows a lot of excitement.

□ "Secondhand" Lighting

The lighting was achieved by taking advantage of the video light that was being used at the wedding. Shot on Kodak TMAX 3200 film, a Canon 85mm f-1.2 lens was used. Partial spot metering was used to avoid the meter taking in to account the dark areas in the photograph and unintentionally overexposing the image.

"I happened to have my camera focused on her face..."

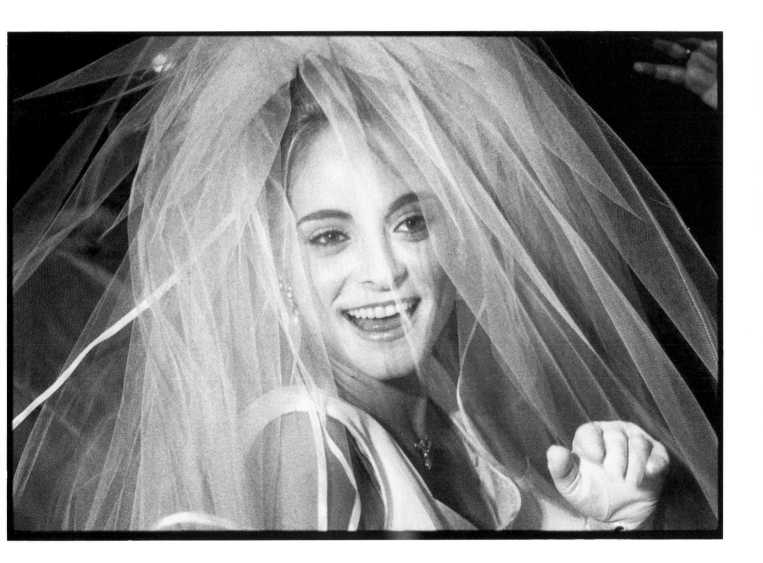

☐ A Favorite Image

This image is one of my favorites. It is also one of the first images I ever took shooting black and white 35mm at a wedding.

☐ Lighting and Composition

The light on the bride's face came from a window in front of the bride and to the left of the camera. What makes this photograph great is the sconce on the wall behind the bride. It just brings the whole image together for me.

☐ Photography

The photograph was shot with the Leica M6 35mm f-2.0 lens on Kodak TMAX 3200 film.

☐ Setting

Shot in the bride's dressing room in the hotel where her wedding was taking place, this was not completely posed, but I had some input. The bride was leaning over a couch to talk with someone. I saw the potential image of her with the sconce on the wall and I liked the composition.

☐ Getting Started

Like anything else that you are trying for the first time, I started out tentatively, experimenting with weddings that did not expect any black & white. I would shoot a few rolls (two or three) and see what came out. Even when I was starting, I always tried to make every shot count and make every one a little different. I don't like to burn film and come away saying I shot 1000 images at a wedding, when only a small percentage are any good. I would rather shoot 200-300 images and have a greater percentage of top-notch shots. This will also make things much more enjoyable for your customer, cut down on production time, and certainly cut down on expenses as far as film processing is concerned.

"What makes this photograph great is the sconce on the wall..."

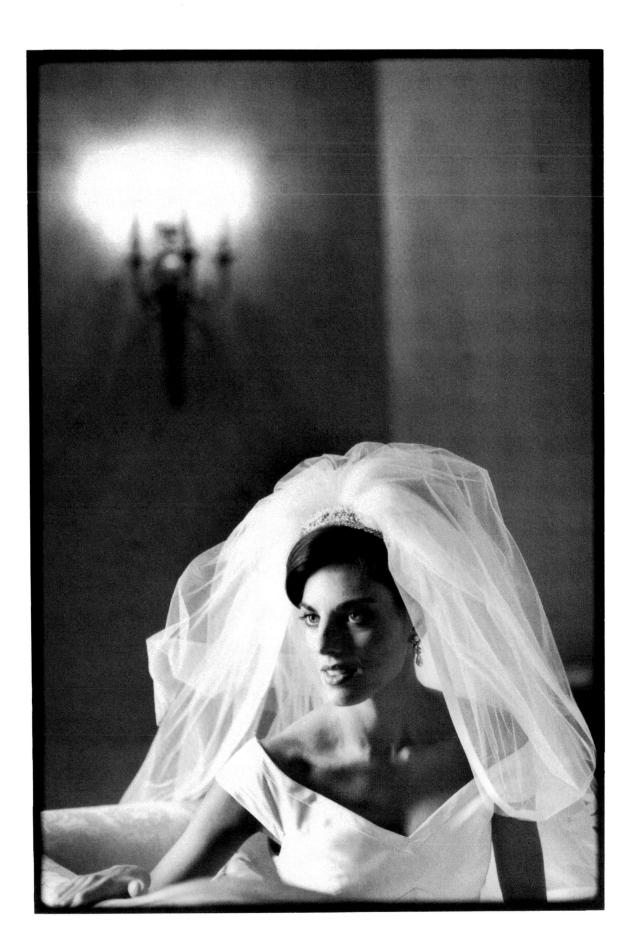

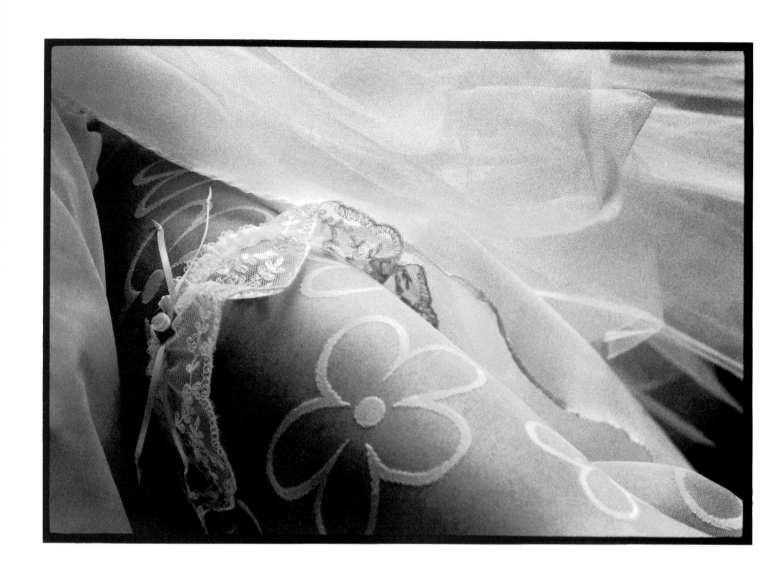

Film Usage

☐ Setting

This was an image I took in the bridal room while the bride was dressing. Lit by window light, I just waited till the bride had slipped her garter on – I liked the pattern in her hosiery. Again, everything in this type of photography has to do with details. If you don't shoot it, you can't sell it.

☐ Photography

This photograph was shot with Kodak TMAX 3200, using a Leica M6 90mm f-2 lens.

☐ Film Usage

I tend to shoot different amounts of film at different weddings. It depends what my clients are looking for. Some want just a little coverage, some want the fullest coverage. I try to anticipate what my brides are looking for and then shoot accordingly. If a bride is looking for just a few photographs in black & white to add to her album, there is no reason to shoot hundreds of images. I would probably, in this case, shoot about four to five rolls of black & white. If the bride wants full coverage of the day, fifteen to twenty rolls of film would be shot.

☐ Presenting Proofs

I have tried several ways of presenting proofs. My favorite is to use contact sheets as they tend to give the best representation of what I was trying to show. I have tried proofing black & white, only to find that the quality of these proofs is not up to par. The exception to this is if I work with Kodak 400CN film. This film proofs really well and allows me to present customers with 4 x 6 images from which they can select.

"If you don't shoot it, you can't sell it."

window light

subject seated

camera placed at a low angle

☐ Covering Large Weddings

Our studio has positioned itself to photograph the most upscale weddings in the New York metropolitan area, as well as nationally and internationally. The majority of the work we photograph is in New York City, though. Many of the weddings that we do are large (i.e. over 250 guests). When a wedding is this large (or larger), I usually suggest adding on (at an additional charge of course) a second crew of photographers. When I say "crew" I mean two people – one photographer and one assistant. When I have the advantage of two crews, I usually have one shoot the traditional color portraits and candids, then I have the second crew do both color and some black & white.

If I should be the only photographer at the wedding, then I will do both traditional photography and black & white. I make it clear before the wedding that if I am the only one shooting, I can't be doing two things at once. For instance, when the bride is walking down the aisle with her dad, I can shoot either in color or in black & white, but not both. I give my clients a few seconds to think about this, then mention that if they really want complete coverage in both color and black & white, they should consider having us bring along an additional photojournalist to shoot black & white exclusively.

☐ A Posed Shot

Here is the exception to the rule. This bride had put her veil over her face and was standing by a window with very pretty light coming in. I decided to take a posed photograph! I loved the look that the texture of the veil gave to the bride's face. I took a shot looking at the camera and one looking away, out the window.

☐ Capturing Personality

I try to capture some of the bride's personality when I work. Obviously, it is nice to make the bride look beautiful, but sometimes it is more than that. One has to try to capture a bride in different moods – and not all of them have to be happy. Serious is just fine too.

☐ Photography

The portrait was shot on Kodak TRI-X 400, using a Canon 85mm f-1.2 lens.

"Our studio has positioned itself to photograph the most upscale weddings..."

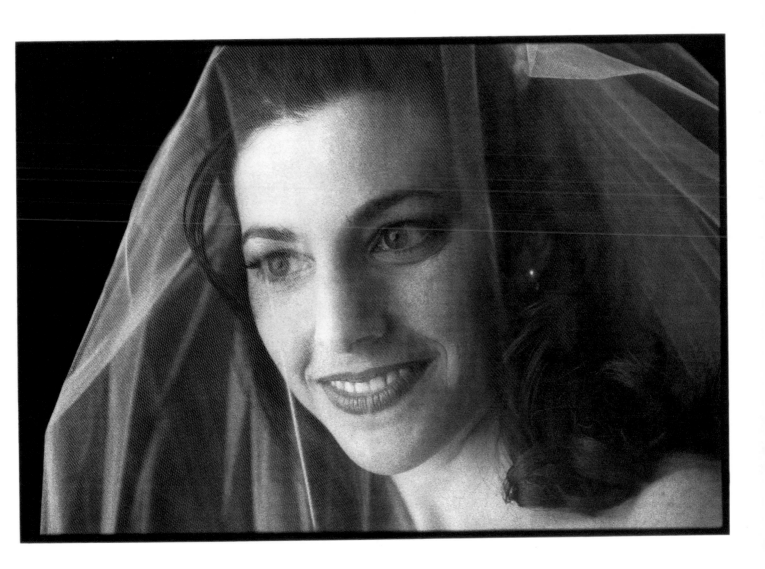

☐ Photography

This is the only image in this book that was shot with medium format equipment. I was shooting some available light photographs with my Hasselblad when the bride turned, and I noticed how pretty the back of her gown looked and how the window light was accentuating the buttons down the back. The image was shot with a 100mm lens on the Hasselblad 503CW.

☐ Film

I put on a film back loaded with Kodak 400CN film. This film is great because it can be processed in C-41 chemistry, but also because of the fun things you can do with it. For instance, you can print it on regular black & white fiber paper or you can print it on color paper and add a tint, as I did in the final presentation of this image. I used a sepia tone which worked well with this subject; however, you can pick any color that you want – green, blue, red. Be aware, though, that if you are printing your black and white photographs on color paper, the images will not have the same archival quality that they would have if printed on fiber paper.

☐ Metering

The image was metered with a Minolta V meter and the film was rated at ISO 400.

"... when the bride turned and I noticed how pretty the back of her gown looked ..."

white wall acts as a reflector

window light

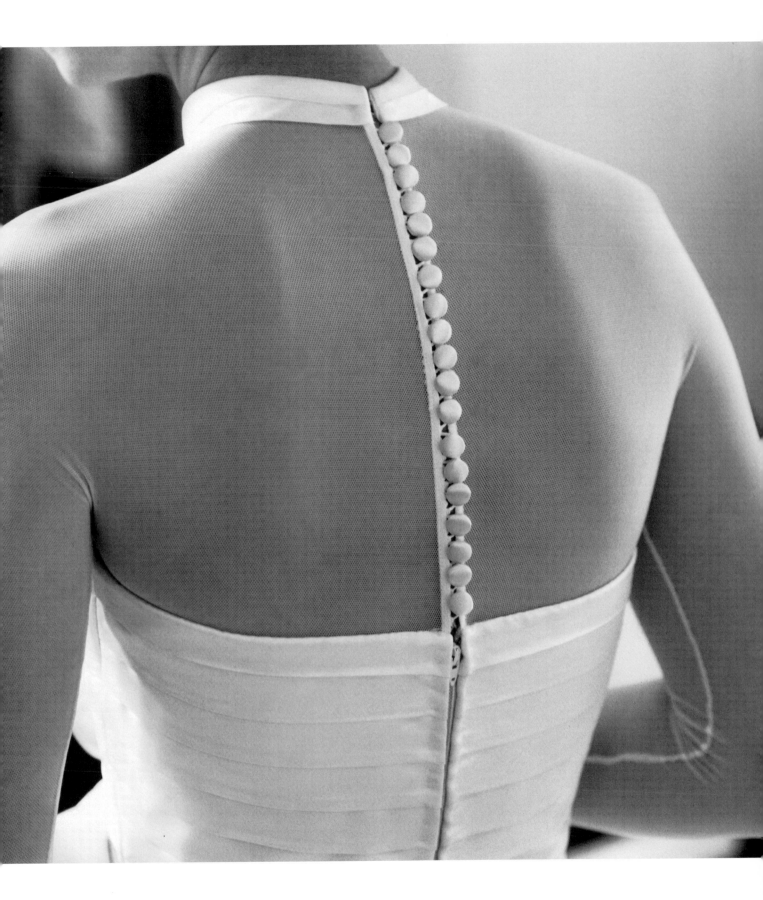

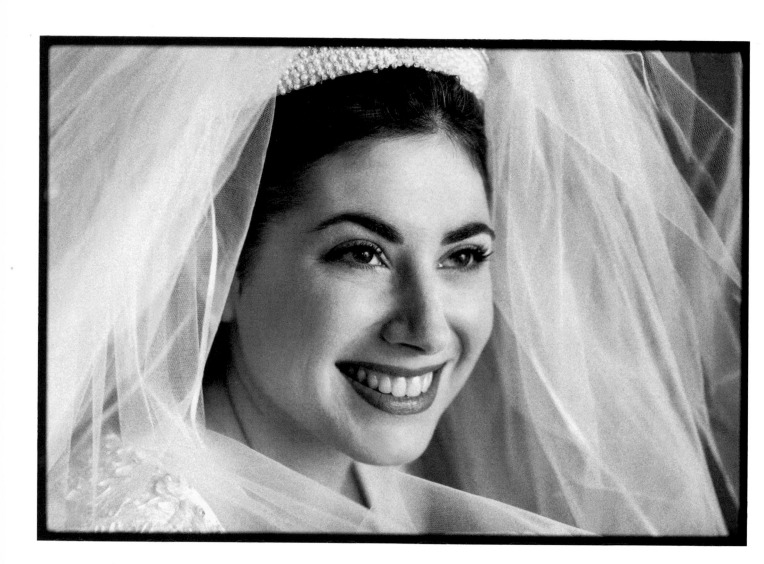

To Pose or Not to Pose
..

☐ To Pose or Not to Pose

I have no set formula for photographing weddings in black & white. I shoot what I feel at the moment. 95% of my wedding photojournalism images are shot unposed. However, if I feel a photograph would look a little better if I adjusted the subject a little, I usually do so. Just remember to keep your interaction to a minimum in order to capture natural-looking images and avoid making your subjects feel self-conscious.

☐ Lighting

This image is similar to the one on page 35 where light from the video set-up was used in the still photography. Here, however, I used the light coming from modelling lights bounced into two umbrellas which we were using to shoot portraits. The subject was unposed.

☐ Composition

I like tight facial images, and this one has the added benefit of showing the bride's headpiece. It's just another detail, but helps document all the planning that went into the bride's wedding day ensemble.

☐ Photography

This portrait was photographed on Kodak TMAX400, using a Canon 28-70mm f-2.8 lens.

☐ Use a Test Roll

The worst experience I have had shooting photojournalism actually occurred after a wedding, when I tried a new lab for processing my film. They had an interesting way of presenting proofs in black & white (instead of the contact sheets that I normally use), and I wanted to give them a try. I sent the film in (Kodak TMAX 3200) and they processed it in such a way that the grain structure looked like baseballs. Needless to say, I wound up quite upset. My customer, however, thought it was really cool and liked the "new technique" I used for her wedding photographs. I learned an important lesson from the experience. Now if I try something new, I use a test roll first. If that is not possible, I will just process one roll as a test, instead of all ten at once.

"I shoot what I feel at the moment."

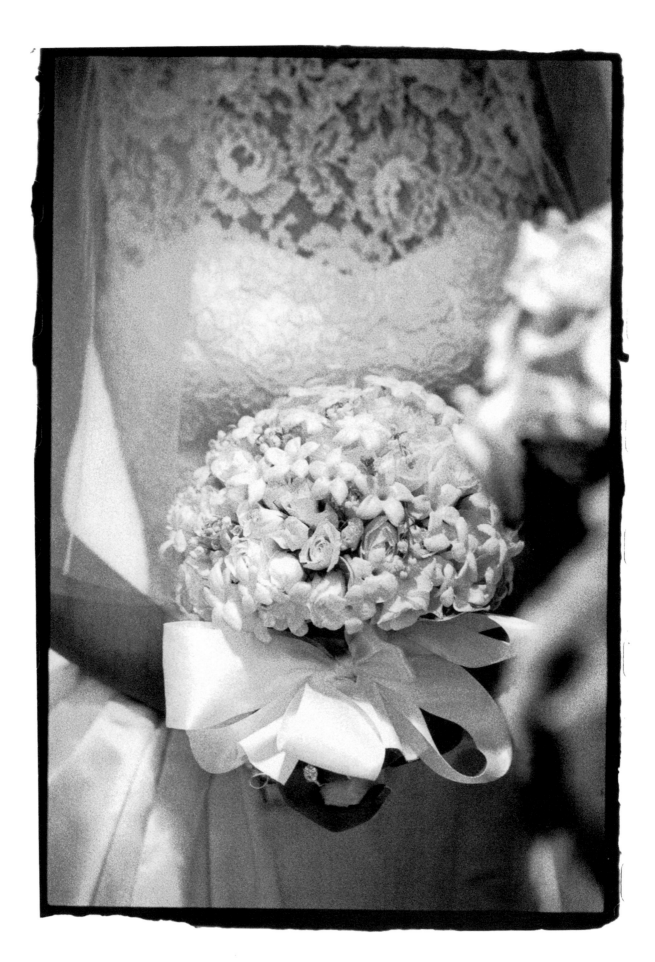

Black & White for Detail

☐ Black & White for Detail

This is another image that shows details of the bridal gown and bridal bouquet. Brides devote many days and hours to selecting just the right dress and just the right bouquet. I like to show these details, which I feel come across much better in black & white than in color.

☐ A Different View, A Different Album

I save the traditional portraits of the bride for the traditional wedding album. Remember, my goal here is to create two different wedding albums for my clients – and the difference must be more than just black & white versus color. If I took traditional, "bride looking into the camera" wedding portraits, they would be too similar to my traditional photography to justify their own separate album. This would give the bride a choice – does she take the black & white version *or* does she take the color version (note, that's an "or" – she probably won't take both). By avoiding the bride's face as much as possible, I can create for her a completely different photographic view to select from.

☐ Photography

Metering for this shot was full matrix and was made with the Canon 85mm f-1.2 lens on Kodak TMAX 3200 film.

"...I can create for her a completely different photographic view to select from."

chandelier lights
the subject
from above

camera placed low

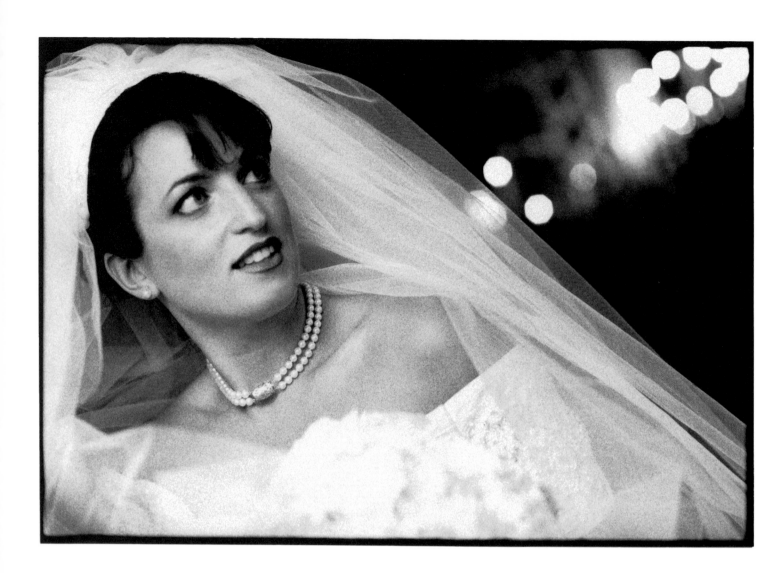

Diagonals and Composition

☐ **Composition**

This was a candid shot of the bride, but it is made very interesting by simply tilting the camera severely. In terms of composition, diagonals give an image a sense of excitement, so I look for them where they exist. When I don't find any, I often create them by tilting the camera. The out of focus lights in the background also form a diagonal line that leads the viewer's eyes to the bride's face.

☐ **Photography**

This portrait was shot on Kodak TMAX 3200 film with the Canon 85mm f-1.2 lens.

☐ **Telling a Story**

When shooting wedding photojournalism, I don't think in terms of shooting a certain target number of images of a subject. Rather, I keep my attention on creating special photographs that capture particular moments during the wedding day. I do, of course, try to keep in mind that I need to capture a little bit of everything – especially of the bride and groom. My attentions are dedicated to covering the story of the wedding day as a whole.

☐ **Staying Organized**

A great system to keep track of which rolls you shoot (in case you have to refer back to a particular roll) is to label each roll with the time it leaves the camera. This works especially well when you have more than one person shooting 35mm at a wedding. Even if you throw all the film in one big bag, you can always sort it out and know in what order it was shot.

All my contact sheets are numbered in the back, (i.e. 64534-1, 64534-2, etc.). The first five digits are the file number for the particular wedding, the last number is the roll number. Negatives are kept in strips of six in glassine envelopes and marked with the job number and roll number. For presentation, I use a china marker to mark all my choices and do a quick edit for my customers, explaining that what I chose is just a starting point and that they should look at all the images and see if there are others that they would like. Most people seem to like what I select, and usually add several of their own choices.

"I keep my attention on creating special photographs that capture particular moments..."

☐ Details Equal Sales

Shooting details of the bride (i.e. hands, ring, veil, dress, etc.) have added a lot to my sales. These images are rarely seen in traditional wedding coverage, mostly because it is difficult to shoot them in a quick manner with the medium format cameras that most wedding photographers use.

☐ Mobility of 35mm

With the exception of the images on page 43, all of the images in this book are shot with a 35mm camera, which allows me to stay mobile and work quickly to capture fleeting moments. While brides are standing around, I move around them and shoot as they adjust their veils and primp themselves. This gives me many more photographs to select from when creating this behind-the-scenes version of their wedding.

☐ Photography

This photograph was taken with the 85mm f-1.2 lens on Kodak TMAX 3200 film.

☐ Printing

I was experimenting here and shot this image about two stops overexposed, then printed down in the final print. This caused the grain to enlarge and give a different look to the photograph. I have found it hard to control the exact amount of grain that you get this way, but it is a fun effect to use on a few images in the album.

☐ Lighting

This image was shot using strictly available light coming from high hats in the ceiling.

"Shooting details of the bride have added a lot to my sales."

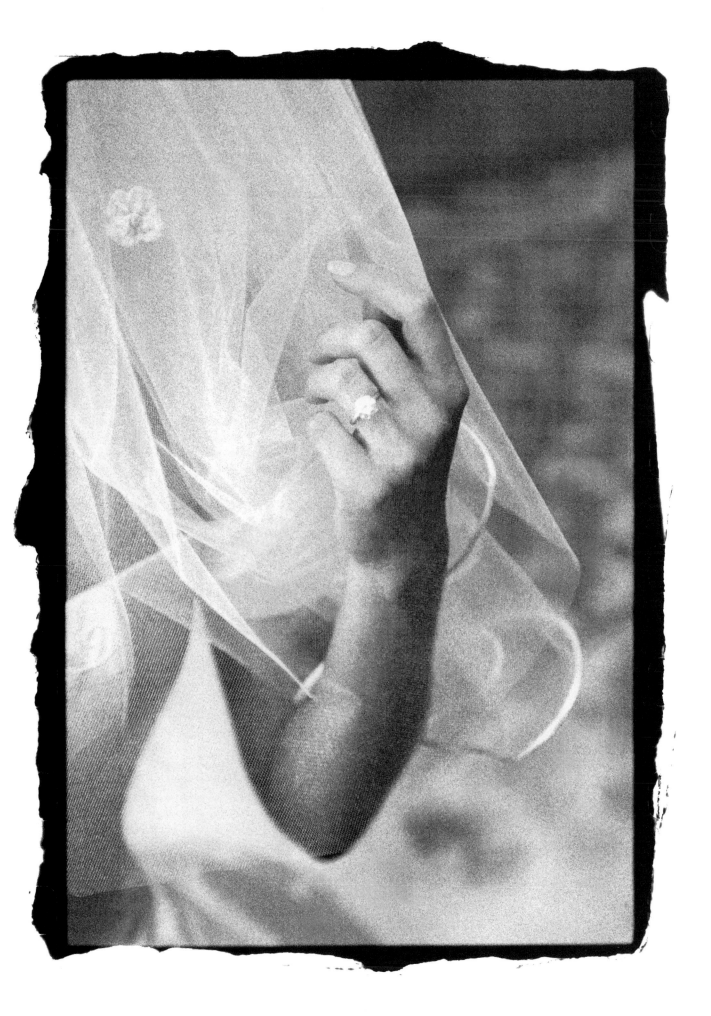

☐ Camera Tilt

Tilting the camera adds some excitement to the image. I tend to tilt the camera a lot. This is called Dutch angles by some in the business. I have no idea where the term comes from, but diagonals do create excitement in an image and when they are not there naturally, I create them by tilting the camera.

☐ Setting

This image was taken during the traditional portrait session. I loved how the bride's eyes were so expressive. I had her hold up her bouquet in front of her face and just peek over it.

☐ Photography and Lighting

Using the Canon 85mm f-1.2 lens practically wide open I was able to focus in on her great eyes without being distracted by any outside details. This image was shot with Kodak TMAX 400 film with available light streaming in from a huge picture window on the bride's right. I had my assistant hold a white reflector to kick some light back into the bride's face.

☐ Developing Your Skills

I think my strongest point is that I understand what I am trying to shoot. In other words, I don't just go into a wedding and shoot everything that moves. I actually feel that there are shots that a traditional photographer should shoot, and there are shots that a photojournalist should shoot. Making the transition in the middle of a shoot is the hard part. It took me a while to get there, and now it is effortless. Practice is the key. I started out shooting some black & white at weddings where it was not requested, then critiquing my work and showing it to clients. I found that the more I shot, the more they purchased. My black & white wedding photograph shows the "micro" rather than the "macro" wedding. I feel that is the key.

"... diagonals do create excitement in an image ..."

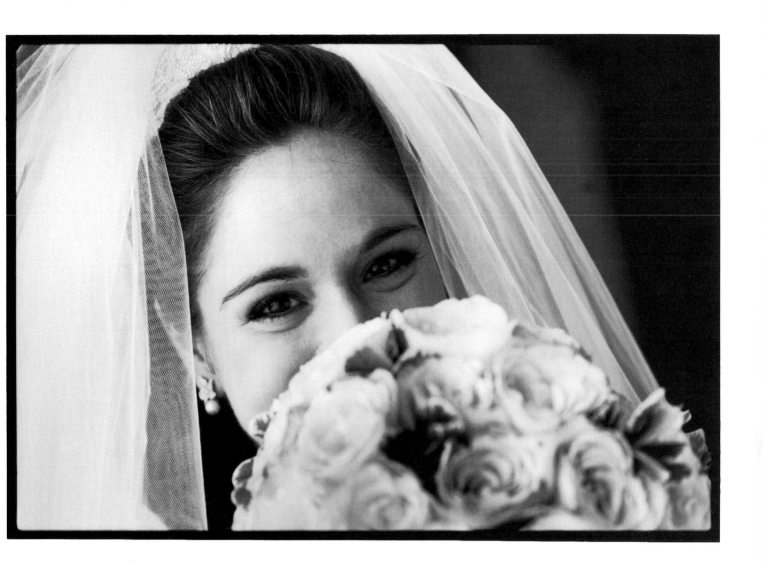

☐ Keep Your Eyes Open

As I've mentioned before, one of the skills needed to take successful wedding photojournalism images is an ability to pay careful attention to everything around you. For example, this image was actually taken while we were waiting for an elevator in the Pierre Hotel in Manhattan. The bride's gown was made of a satin fabric, which created great highlights and shadows as the light hit it. I was behind the bride and shot a couple of images to show details in the gown.

Again, shots like this are an addition to traditional portraits that we take at the wedding. I always make sure that the parents and grandparents have the beautiful portraits of the bride that they expect, but you can clearly see how capturing these details also provides a uniquely personal and meaningful addition to the traditional images.

☐ Photography

This image was shot on Kodak TMAX 3200 film, using the Canon 85mm f-1.2 lens. This particular lens is amazing because it allows you to work at a decent shutter speed even in the lowest of light. It also lets you have very selective focus because when you are shooting wide open, not a whole lot is in focus. Here, this tends to draw you even more into the details of the gown.

"... this image was actually taken while we were waiting for an elevator ..."

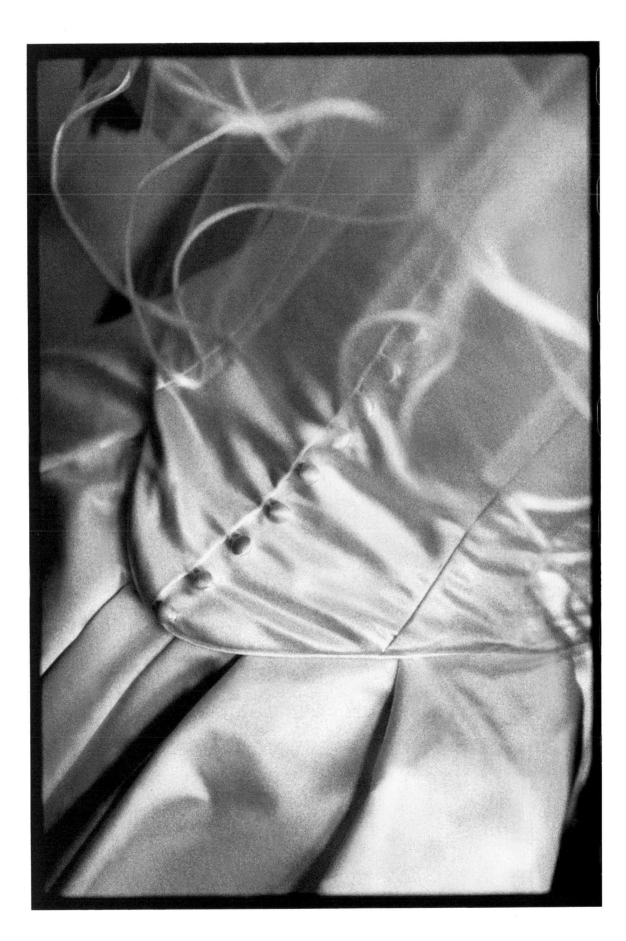

Children at the Wedding

Anticipating Action

☐ Setting

Children are the greatest subjects. Color or black & white, they can always be relied on to provide you with some innocent look or adorable situation. This photograph of twins was taken as the bride was walking down the aisle. These two were just sitting there waiting and, when the bride made her entrance, they both simultaneously covered their mouths.

☐ Anticipating Action

It only lasted for a second, yet I knew something was going to happen between them. This comes with practice. The ability to anticipate events before they happen is a skill that separates good photographers from those that just shoot pictures.

☐ Photography

This image was captured on Kodak TMAX 3200 film using the Canon 85mm f-1.2 lens.

"...when the bride made her entrance they both simultaneously covered their mouths."

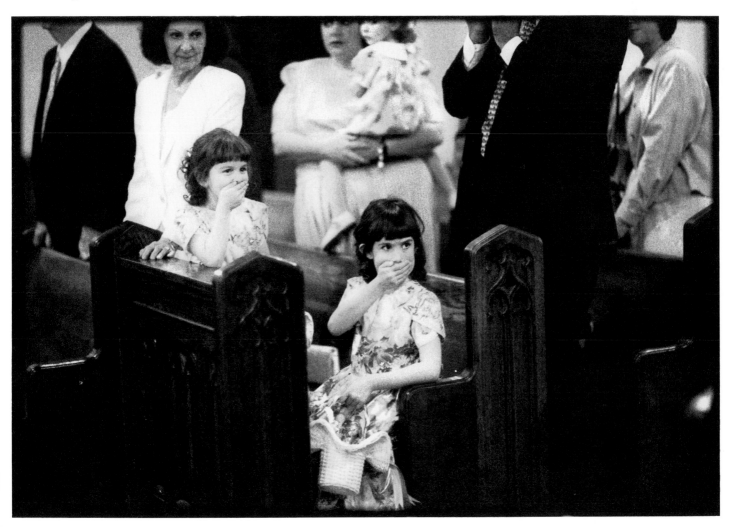

☐ **Right Place, Right Time**

Here again is an image that was just grabbed, as many are, as I was going to prepare for the ceremony. People were standing around waiting for the ceremony to begin, and this image just came to me.

☐ **Be Prepared**

I always try to keep a camera with me. If I am not holding my Hasselblad, I will carry my Canon or Leica. You never know when something will appear in front of you. I saw this young man, obviously bored, climb on this couch and look out the window, and I snapped the picture.

☐ **Composition**

The white reflection of the ceiling on the window pane helped by making his head stand out from the dark background.

☐ **Photography**

The portrait was shot on Kodak TMAX 3200 film, using the Canon 85mm f-1.2 lens.

☐ **Evolving**

I try to look for new ideas every day. I look at what the fashion photographers are doing. I try new techniques, work with different labs, etc. When I find something that works, I include it in my repertoire of shots. As my style and techniques have evolved, my average album in black & white has shot up from twenty to thirty images to over eighty. The most I have sold to this point is 225 images in two volumes. Remember, this is in addition to the color coverage that we give our brides. Usually the bride and groom order an album in black & white, then when the parents see the images, they order an album too.

"You never know when something will appear in front of you."

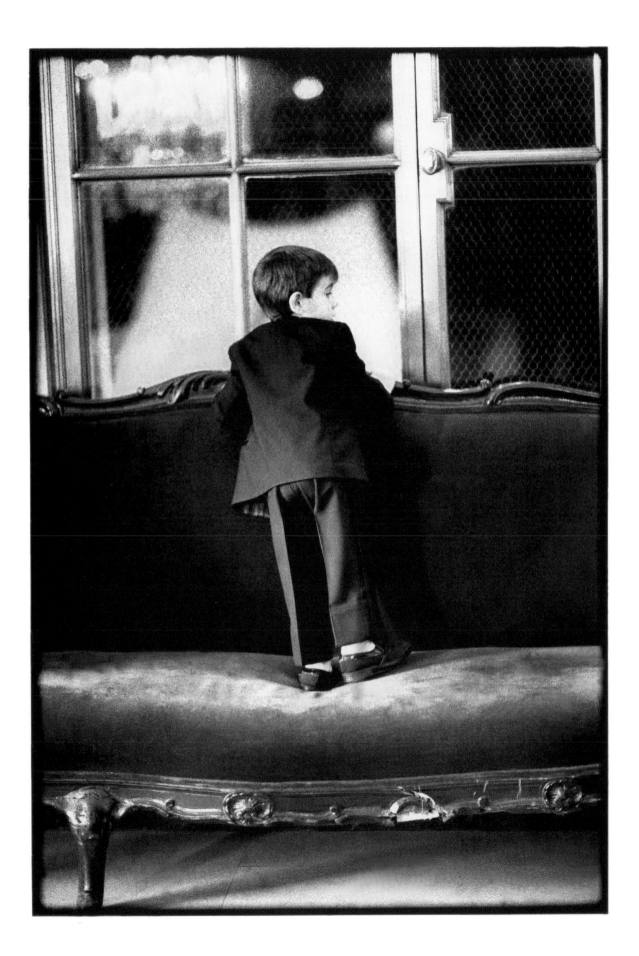

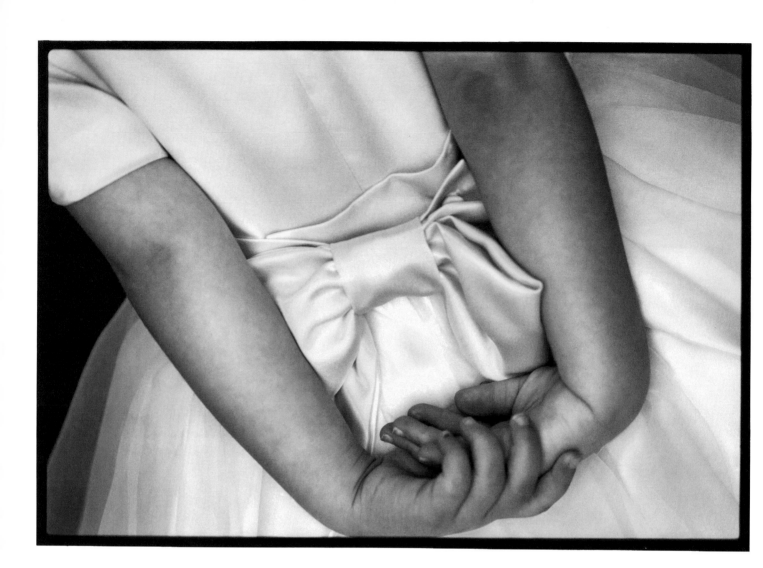

A Spontaneous Moment

☐ A Spontaneous Moment

This flower girl was waiting for her pictures to be taken, and she was really just standing around. She did not know that I was photographing her, as I was standing behind her. I was set up for a shot to show the detail in this flower girl's dress, when all of a sudden she reached behind her back and clasped her hands. Kids' little hands are so delicate and just great to photograph. It was such a cute gesture, and also served to frame the bow on her dress. This is another of those detail-type shots that seem to sell so well for me. Tilting the camera added a little excitement.

☐ Photography

The image was shot on Kodak TMAX 3200 film using the Canon 85mm f-1.2 lens.

☐ Lighting

The only illumination used for the image was available incandescent lighting coming from high hats in the ceiling.

☐ Getting Started

People know that our studio has always had the reputation of doing the finest work for the *crème de la crème* of New York society. We always have done what you would call traditional color wedding photography. We were always successful at what we did; my clients were happy and we were making a good living. It's easy enough to get set in your ways and not want to rock the boat. However, I saw many brides coming into our studio asking if we photographed in a photojournalistic way using black & white film. I decided that I could do at least as well, if not better than what I had seen out in the market. I made the decision to give it a try.

"... all of a sudden she reached behind her back and clasped her hands."

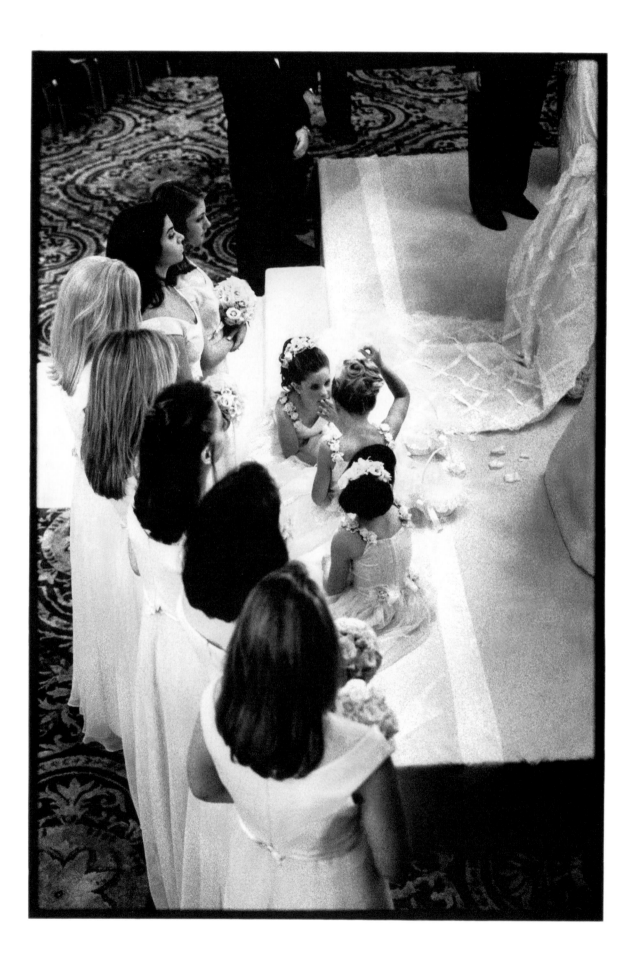

Always on the Look Out

☐ Always on the Look Out

This is a great image that I caught just by staying aware and keeping my eyes open. The photograph was taken at the Plaza Hotel in New York. I had shot the procession and then taken a couple of images from behind the officiant at the wedding. After I had these photographs, I walked up a small staircase to a balcony that overlooked the ceremony.

My intention was to walk around to the back of the ceremony and shoot a few additional images from the back. On my way to the back of the room, I noticed these two flower girls, oblivious to the ceremony and carrying on a little private conversation. God only knows what they were talking about – everyone was paying attention to the ceremony except these two! I took a quick shot, then proceeded to the rear of the aisle to complete the intended shots.

☐ Photography

The film used to capture this image was Kodak TMAX 3200. The lens used was the Canon 28-70mm f-2.8.

"This is a great image that I caught just by staying aware and keeping my eyes open."

spotlights

lighting from under the bridal canopy is reflected into the faces of the children

spotlights

Details, Details, Details

☐ Details

Details, details, details. Again, another detail shot showing a little flower girl's shoes. They looked cute, so I took one shot and moved on. Keeping an eye open for details paid off here, since the image was chosen by the bride for her album.

I found the shoes as I was exploring the bridal suite where the bride was getting ready. I like to walk around and look for things to photograph – the wedding gown, the bride's shoes, her garter, her jewelry, etc. Everything is game for a shot. However, I also try to find things that are interesting and personal to photograph. A great shot I look for is a bouquet of flowers that the groom may have sent the bride. I take a shot of the flowers with the note that he sent along. It's a sure seller.

☐ Photography

The image was photographed using Kodak TMAX 3200 film, and the Canon 85mm f-1.2 lens.

☐ Film

An important thing to learn is the limitations of the films that you work with – what they can do and what they can't. I feel that you have to know your film backwards and forwards. You should be able to go into any situation and, without a light meter, be able to come back with useable exposures. I have always felt that equipment, film and flash (if used) should be second nature to the photographer. One must concentrate on observing moments and not on figuring out how to use the camera or what the exposure should be.

"... the image was chosen by the bride for her album."

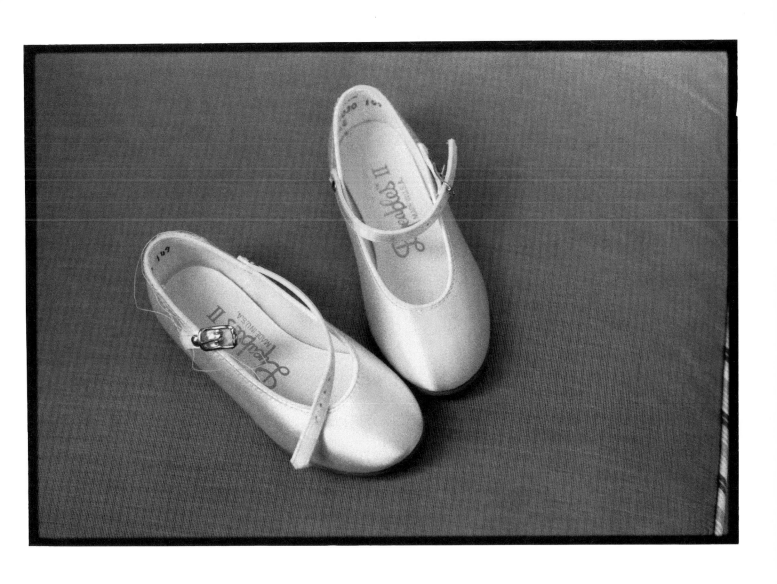

The Flower Girls and the Bride

☐ Setting

This picture was taken outside the Plaza Hotel in Manhattan. We went out to take some traditional photographs of the bride and her bridal party on the streets of New York. I like doing this because New York affords so many different opportunities to create great images.

On the way back into the hotel, I had my assistant take my Hasselblad and I grabbed my Leica. I asked the flower girls to help the bride carry her dress, which they gladly did. As we walked back to the hotel, I took a few shots because it looked so cute. The people in the background, the usual crowd you get on a late Saturday afternoon in New York, just add to the excitement.

☐ Photography

This portrait was shot using Kodak TMAX 400 film and the Leica 35mm f-2.8 lens. Matrix metering was used.

☐ Sales

My studio has a special area that has been set up with beautifully framed photographs in black & white. This area does all the selling I need. People look at the photographs, see the emotion they evoke and ask if they can have that in addition to what we normally do. I explain my feeling that this type of photography does not replace traditional portraiture and that it should be used as an addition to the traditional coverage. I try to see if they really understand what they are looking at, and that it is really something that they want to have. Then I try to see how much of this they really want. Price can be an important factor, as this is an addition to a product that is already expensive to begin with. I have been fortunate to have clients with whom budget is not always the issue. Rather, they can concern themselves purely with capturing the emotion and love between two people.

"The people in the background ... just add to the excitement."

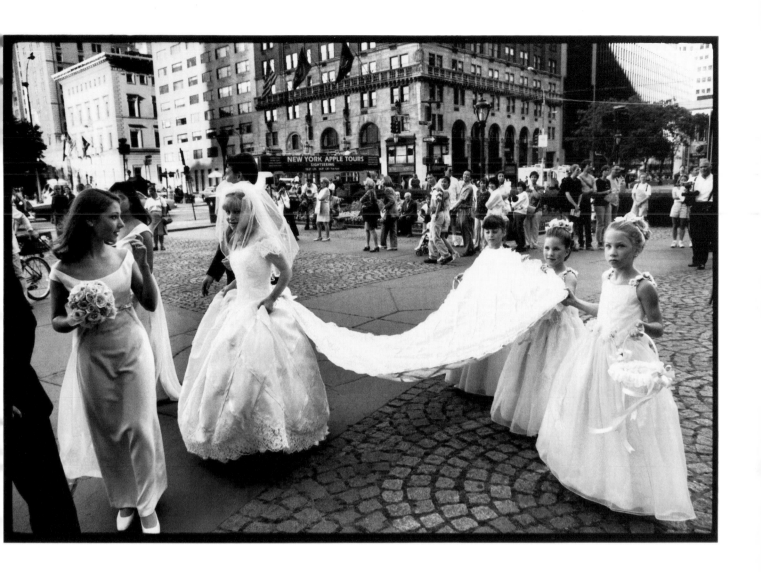

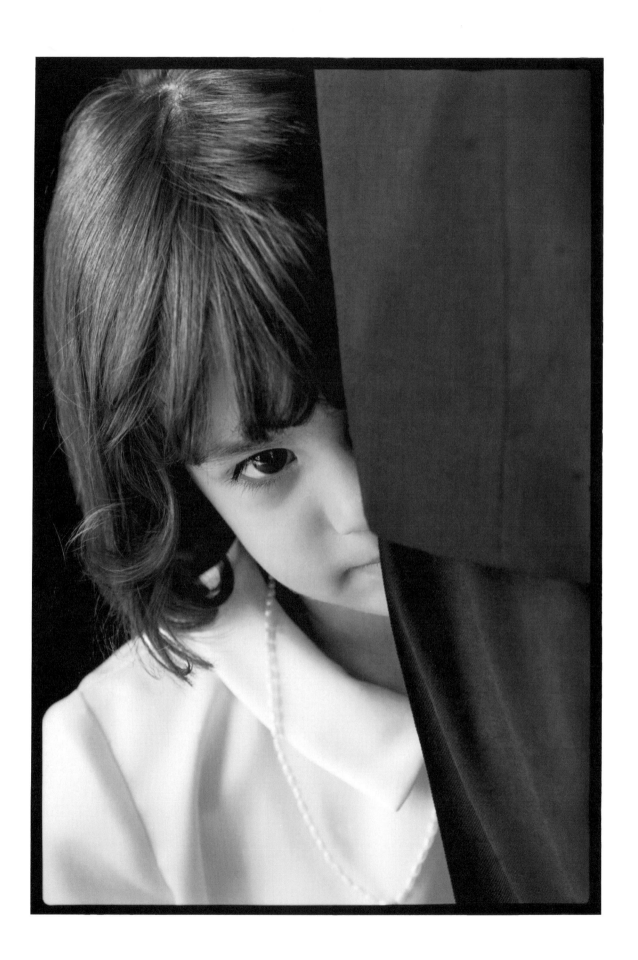

A Little Shy

☐ Shyness

This little girl was the bride's niece and she also was a flower girl. I wanted to take a picture of her and her sister, but she became a little shy. She ran behind her dad and grabbed onto his leg for dear life. I gave it a minute and grabbed my 35mm camera. I walked over and played peek-a-boo with her. She peeked out and – click – I grabbed the shot. I love the innocence of it.

☐ Working with Kids

Kids are interesting to photograph, and the best advice I can give is that you must have patience – lots of patience. If you let them be, they always come through for you. When I photograph in a traditional manner, I like to get on my knees, down to their level, and talk with them, play peek-a-boo with them – anything to get their attention. In photojournalist mode, I will just watch and wait for them to do something cute.

☐ Photography

This image was shot on Kodak 400CN film, using the Canon 28-70mm f-2.8 lens.

☐ Kodak 400 CN Film

Kodak CN400 film is lots of fun to use. The beauty, of course, is that you can send it out with your color work and get back regular proofs. After showing clients the images, you can decide whether to print on black & white paper, or as tints (printing the images on color paper). When you do print in color, you should be sure to communicate to your lab exactly what you want.

"She ran behind her dad and grabbed onto his leg for dear life."

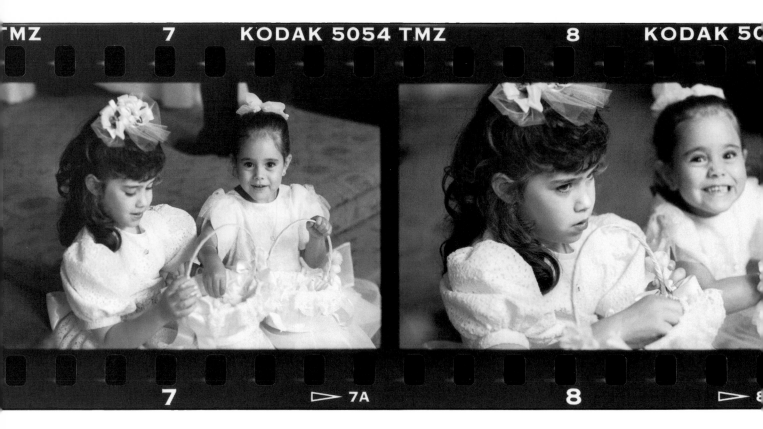

Shooting a Sequence

☐ Shooting a Sequence

Used as a panoramic photograph in the bride's album, this image of two flower girls was taken just before the bride walked down the aisle. I was standing to the side of the aisle as the kids were sitting waiting for the bride to enter. These two were sitting on the steps of the altar playing, and one took a flower from the basket of the other. She noticed that I saw her do this and gave this sheepish smile. I was shooting all of this with a sequence in mind.

When I saw the one flower girl reach into the basket of the other, it was just so cute. I smiled at the little girl when she took the petal, and she saw me and smiled back. I zoomed in for the second image of her expression. Using zoom lenses is great for letting you come in for a great close-up.

☐ Photography

Kodak TMAX 3200 film was used for this shot, with the Canon 70-200mm f-2.8 lens. The lighting for the photograph was natural and very low, and thus was taken at a very slow shutter speed.

"She noticed that I saw her do this and gave this sheepish smile."

ceremony
taking place

chairs

spotlights on
the ceremony

☐ Getting Great Expressions

This shot was taken in front of the Plaza Hotel in New York. It was one of those semi-posed shots, but the part that was posed was the kiss, not the flower girls holding the bride's train.

When I asked the bride and groom to kiss, the expressions on the children changed immediately. It was very cute. I took a couple of images, and then we proceeded to go back to the hotel with the kids still holding the train. Sometimes giving kids a little responsibility will yield great results.

"... the expressions on the children changed immediately."

☐ Photography

I shot this image with a Leica 35mm f-2.8 lens on TMAX 400 film. I was on my tiptoes trying to shoot down to get a better angle on all the subjects in the scene.

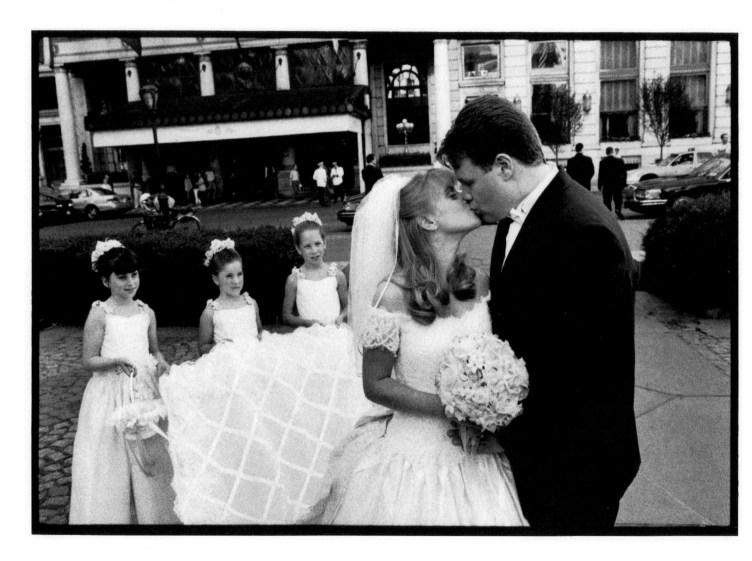

Taking to the Streets

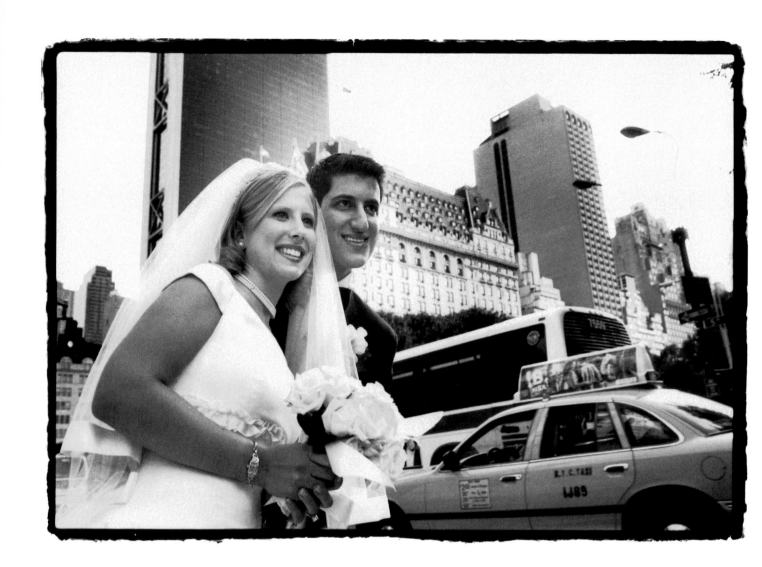

☐ Portraits in the City

This portrait was taken outside the Pierre Hotel in New York and was actually part of our traditional portrait session that we do with the bride and groom. Although it would serve as a good model for an interesting exit shot, we generally do shots like this before the wedding. We especially like to go outdoors and do some fun environmental photographs that show Manhattan. This sometimes takes a little convincing because some brides worry about their dresses getting dirty or that it is too warm and their hair will look bad. I never push, but I do point out how their photographs will look different than their friends' photographs.

☐ Photojournalism

While one of my photographers was shooting the image for the couple's "traditional" album, I simply moved off to a different angle and bent down to get a low angle on my subjects. I wanted to get the famous Plaza Hotel in the background and a little of New York traffic too. I waited a couple of seconds for a cab to pass by and took my shot. The city bus was an added bonus.

☐ Photography

This was shot with the Canon 17-35mm f-2.8 lens on Kodak TMAX 400 film.

☐ Lighting

Lighting was late day sun coming from the west and the image was metered in the partial matrix mode to avoid the sky taking over the exposure.

"I do point out how their photographs will look different than their friends' photographs."

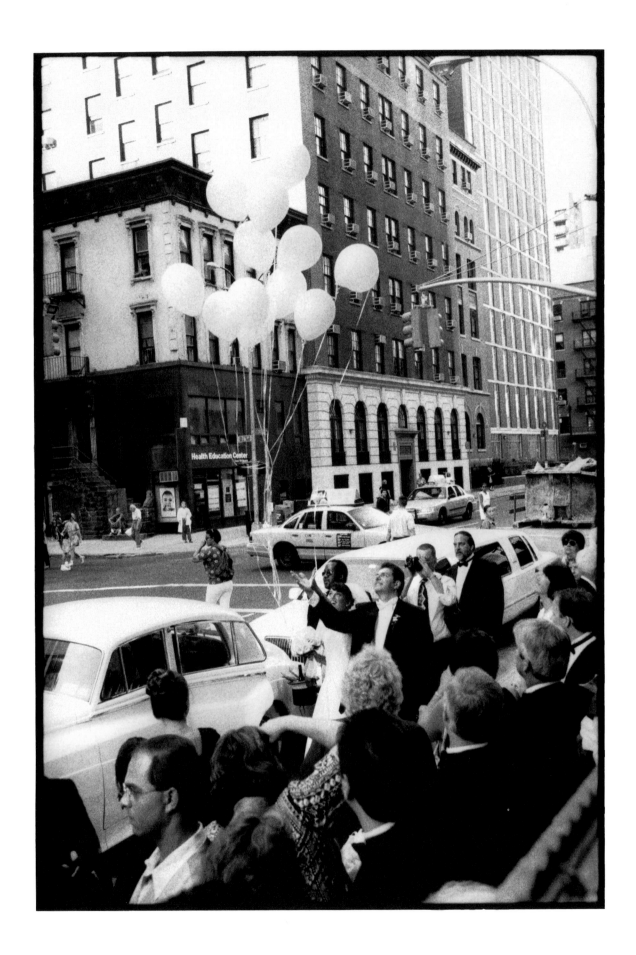

Opening and Closing Shots

☐ Setting

This image was made as the bride and groom were about to leave the church where their ceremony had taken place. I was standing on the steps of the church, and waited for the bride and groom to release the balloons. I shot the image at the exact moment they did. Framing the guests as they watched was also planned.

☐ Opening and Closing Shots

There are many shots that work as closing shots, and for that matter, opening shots for different sections of the wedding album. For the ceremony, one might shoot an opening shot of the bride arriving at the church with her dad. For a closing, something like this balloon release, a limo shot, or the guests throwing rice would be appropriate. There are many possibilities that present themselves. You, as the photographer, just have to be in the right place with the right lens. Some of these images can be discussed before the wedding; however, I still always keep my eyes open.

☐ A Fun Exit Shot

The most fun exit shot I ever took was actually something I incited myself. We were planning to photograph a wedding at St. Patrick's Cathedral in New York and then had to proceed to the reception at the bride's home on Long Island. The ceremony was late in the day and the bride wanted some formal portraits taken during the ensuing portrait session. It would have taken too much time to drive out from Manhattan to the home and still have light for portraits. In our pre-wedding chat, I mentioned that we should have a helicopter fly us out. The bride said, "Great idea!" and wound up hiring two helicopters to fly the whole bridal party out to their estate. This was so cool – and as you can imagine, made for wonderful photographs.

☐ Photography

This image was shot on Kodak 400CN using available light and the Canon 70-200mm f-2.8 lens.

"... you as the photographer just have to be in the right place, with the right lens."

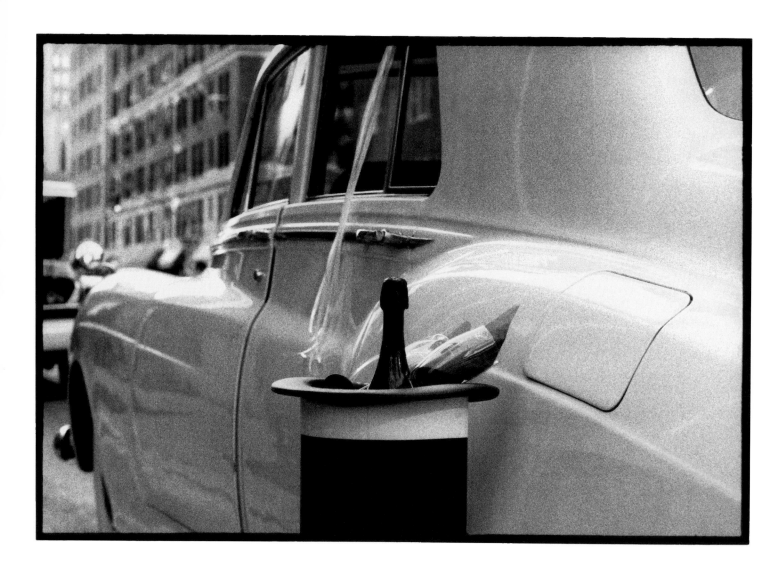

Pricing

☐ Pricing

Pricing is important. It took me a while to learn how to price my black & white so that it would not only sell, but so that our company would make a fair profit. Black & white photography costs substantially more than color, and if you don't price it high enough you will wind up losing money. However, if you price it too high, people will not order photographs. Finding the right balance takes some trial and error. Part of the solution, however, is to educate your customer as to why black & white costs so much more than color to produce.

☐ An Unusual Image

This image was actually taken right before the last image, on page 76. The wedding ceremony was over and I was waiting for bride and groom to exit the church. While the receiving line was going on, I went outside to stake out my shots for the bride and groom's exit from the church. I saw this bottle of champagne in the wine cooler besides the Rolls Royce. I had never seen this before and decided I would take a photograph.

I proceeded to find out if anything special was about to happen when the couple came out of the church. Someone mentioned the balloon release, and I went to find a good spot to photograph that.

☐ Photography

This shot was made with the Canon 28-70mm lens on Kodak TMAX 400 film, using available, late afternoon light. The lens was set at 28mm to accentuate the lines of the car. I try to find different angles to make my images interesting and special. I try not to shoot straight on if at all possible, although I will if it means the difference between getting and losing a picture.

"I had never seen this before and decided I would take a photograph."

Get Outside and Have Fun

☐ Get Outside and Have Fun

This is was one of the fun type of shots I like to do on a nice day in New York City. New York, unlike California, Florida or a good part of the rest of the country, does not have the best weather year round. So, when the weather is good, I like to take the bridal party outdoors and do some shooting. In Manhattan you can have so much fun, and it makes the wedding album a little unique. As a matter of fact, one of my images from a session like this will be used in the Disney movie, "Inspector Gadget," coming out the summer of '99. This particular image was taken on Fifth Avenue in Manhattan. We had the whole bridal party on the curb. They were having fun and I was creating images. It's just a cute shot, and one that also wound up in the bride's album

☐ Photography

This image was shot on Kodak TMAX 400 film with a Canon 17-35mm f-2.8 lens.

☐ Composition and Presentation

I like to fill the frame with exactly what I want. One reason for this is that the films I use tend to become grainy with any large amount of enlargement. So I crop to fill the frame. I also like to present my photographs with the straight-edge black border. This can only be achieved when the entire image is used uncropped (unless you work with a computer). This presentation is, of course, one of personal taste. Some photographers I know use sloppy borders and some use no borders. I tend to like to print my images as 5 x 7's on 8 x 10 paper. I like the look. I mount the final images in a permanently bound album manufactured by Leather Craftsmen in Farmingdale, NY.

"... you can have so much fun and it makes the wedding album a little unique."

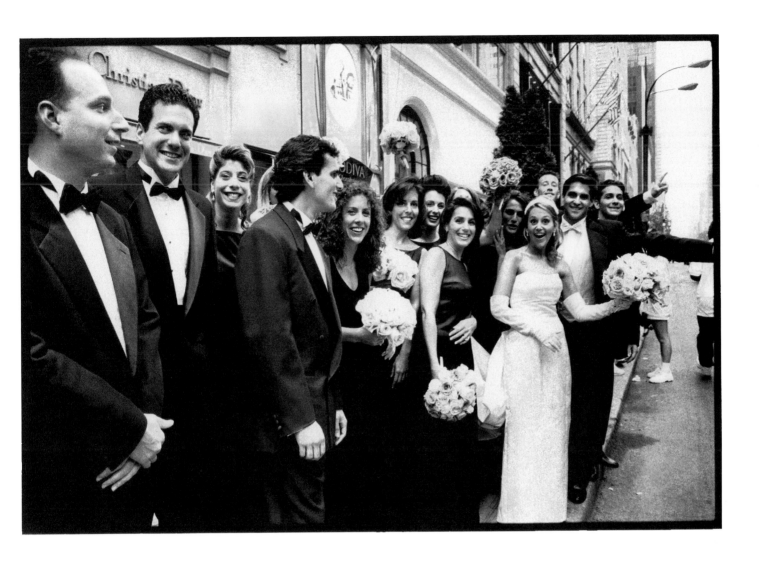

Kisses

☐ Kisses

This is an image from the same wedding as on page 78. Here, the bride had just arrived at the church and was about to get out of the car. Her dad leaned over and gave her a kiss on the cheek. I framed the shot with the car window, even though I was tempted to make it an extreme close up. This is a good shot to lead you into the ceremony, and it always sells. I also try to look for the bride and groom kissing, or them kissing their parents. These shots take very little effort to sell and occur frequently at most weddings. You just have to anticipate them and be ready to shoot when they occur.

☐ Photography

This was made with the Canon 85mm f-1.2 lens and Kodak TMAX 400 film.

☐ Metering

I shot with only available light and metered with the partial matrix mode on the camera because I did not want to have the bright background influencing my exposure. I change my metering modes often during the course of the wedding. For even lighting, I use full matrix metering. For a large, evenly lit area with bright or dark surrounding areas, I will use partial matrix metering. If my subject is being lit with a bright light (i.e. video light), I will use the spot metering mode.

"These shots take very little effort to sell ..."

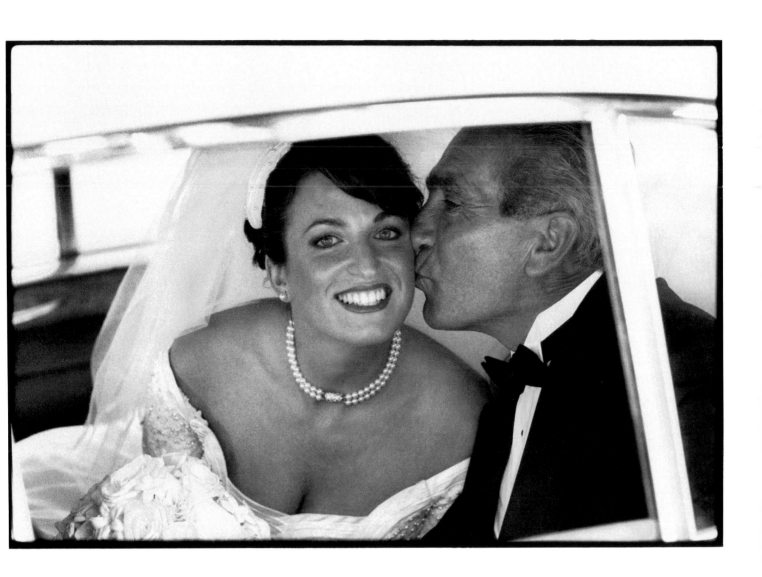

☐ **Creative Location Photography**

This was taken as part of a series of shots we did for a couple on the streets of Manhattan. They had requested that we take some shots outdoors and were actually wide open to any suggestions that we had. This happened to be the weekend of the New York City Marathon and the city was hopping.

We left the hotel where the wedding was being held and walked across the street. I saw the double decker bus sitting waiting for passengers. I asked the driver if he would mind if we used it for a couple of minutes for some shots. He agreed, and we got the bride and groom up on the top and set this shot up. Unfortunately, we did not have a lot of time. If we did, I probably would have done a few more things like zoom the lens out as I pressed the shutter to give the appearance of motion. Nonetheless, they were happy with this version.

After the bus, we went to an area where some bleachers were set up for onlookers to watch and cheer on the runners. We had the bride and groom sit in the bleachers and shot from a distance, getting just them and the entire empty bleacher section. We also had them make believe they were running in the race in their bridal clothes with a big New York City Marathon sign above them.

☐ **Photography**

Thus shot was made on Kodak TMAX 400, using the Canon 28-70mm lens with only available light.

"They had requested that we take some shots outdoors..."

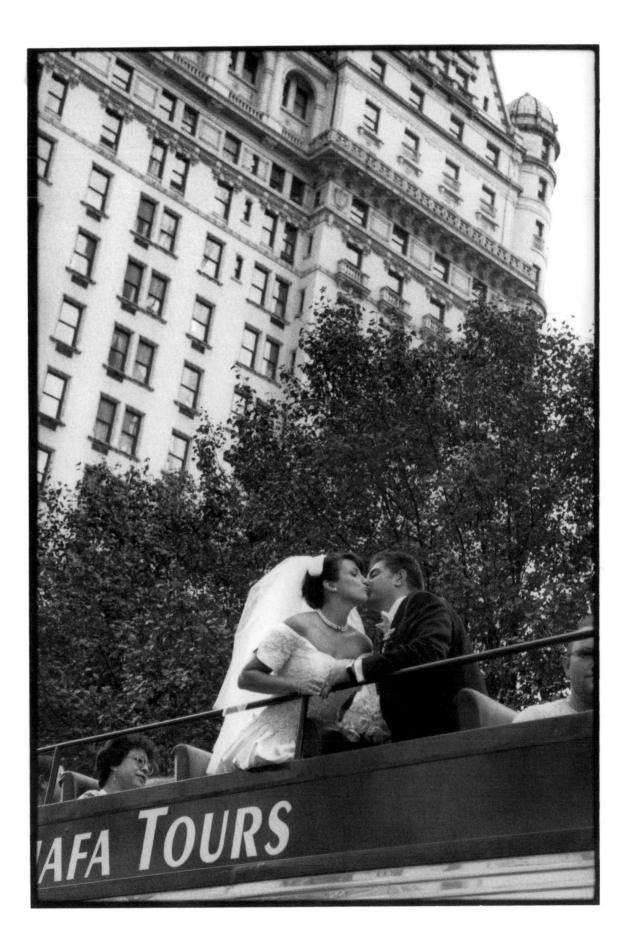

Portraits of the Couple

Be Prepared

☐ A Spontaneous Moment

I was in the middle of photographing this beautiful bride when the groom walked into the room for the first time. I immediately picked up my Canon and started shooting. I followed him and watched his expression. He walked up to the bride, took her hand and kissed it. It was a touching moment – but I had to anticipate it. I had been using my Hasselblad, but when I saw this "first meeting" about to happen, I grabbed my 35mm because of the flexibility it allows in zooming in and out.

☐ Evolution in the Field

Wedding photojournalism, the way I like to see it done, certainly has become more popular in the last five years. This is due to the trends in advertising, where more and more ads are being done in black & white. I remember a few years ago when black & white was viewed as something your parents or grandparents had for their weddings. Now it has become very chic to have this type of photography done at your wedding. As the saying goes, "Everything old is new again."

> "...I immediately picked up my Canon and started shooting."

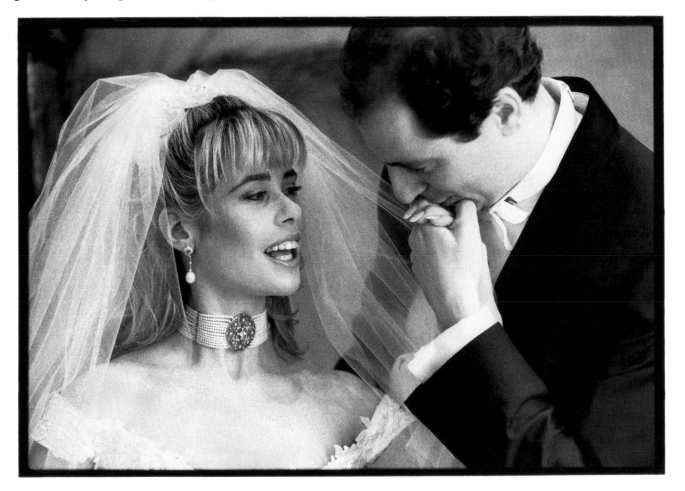

Finding a Unique Viewpoint

☐ Setting

This image was taken inside the home where the wedding was taking place, as the bride and groom were starting their first dance. I wanted to do something different, rather than just shoot the bride and groom looking into the camera. I had the advantage of working with a little faster shutter speed than I normally do, due to the fact that the room was very bright. Light was streaming in from a big picture window. It was also easy to walk around, because the couple had just moved into this, their new home, and there was very little furniture. I decided to focus on their hands and the feeling that they evoked.

☐ Photography

I used the spot metering function on my camera to get the exposure. This image was made with a long 300mm lens, again, so as not to disturb their dance and to be able to stay at a distance. It was shot with Kodak TMAX 3200.

☐ The Future

I don't know if wedding photojournalism is here to stay or not. I sometimes think it is a fad that it will go away in a few short years, but sometimes I feel it is going to last. People's tastes change as they personally grow and change. The influence of the media (print and television) also has a strong impact on the way people's tastes evolve. I do feel that the next big change in wedding photography will occur with digital photography. This is still a few years away, but it will eventually happen.

"I had the advantage here of working with a little faster shutter speed than I normally do..."

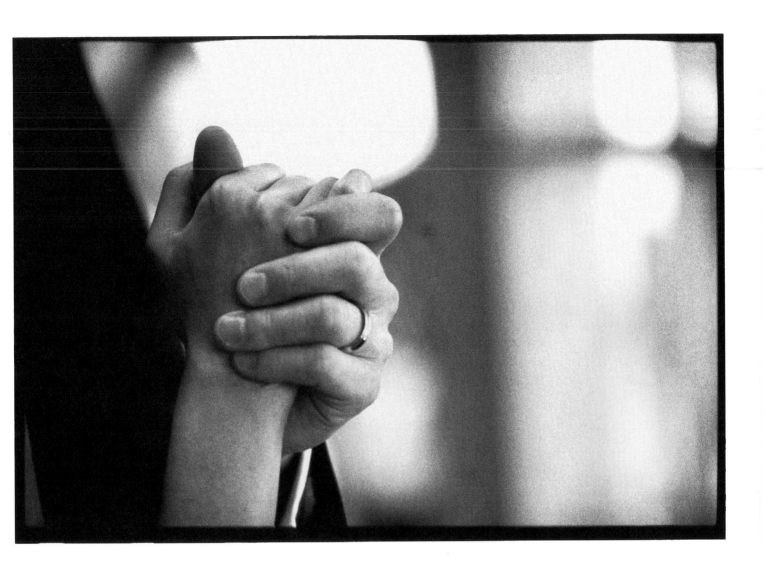

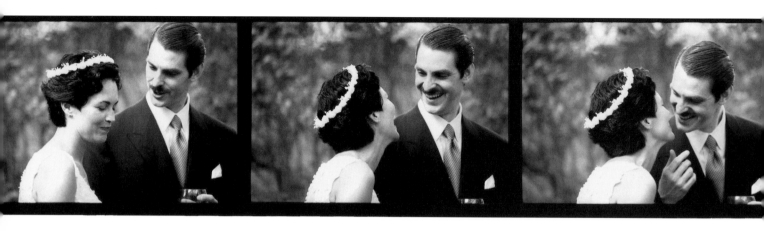

Telling a Story

☐ Opportunities to Capture a Moment

This is a series of photographs (something I take great pains to look for) that tell a little story and capture a private moment. I have found the best times to take such shots are the first time the bride and groom see each other, when the bride and groom return down the aisle, the first dance, and the cake cutting ceremony. Again, this shot was made with an extremely long lens so as not invade the privacy of the couple. One must remain unobtrusive.

☐ Photography

This series of frame was shot on Kodak Tri-X 400 film, with a 100-300mm Canon lens.

☐ Working on the Sidelines

While our traditional color photography is going on, I am usually shooting in the vicinity. I look for moments that are happening along the fringe of the action – a mother fixing someone's tie, a grandmother chatting with a family member, a flower girl or ring bearer doing something cute. These "moments" take place all day at the wedding. They just don't always happen right where the action is. It is rare that everyone in the bridal party is tied up at the same time taking photographs. Usually only a small percentage of the principle people are being used for portrait photographs at any given time. This leaves many people standing around, and they are fair game for some "behind the scenes" photographs.

"...tell a little story and capture a private moment."

☐ Photographing the Groom

The groom is sometimes the forgotten person at the wedding, since most of the attention is focused on the bride. She is the one in the beautiful gown that can be photographed in so many ways. The groom is in a suit or tux which presents more limited opportunities. Still, you have to show a good number of photographs of the groom to be able to sell them.

To capture this image of a happy groom, I just waited and had my camera ready – anticipating the moment. I shot this from quite a distance and used a long telephoto lens to capture the right instant. If you look for moments (expressions, feelings), they will come to you. You just have to have the patience to wait for them to appear. When I work in this way, I am not looking just to shoot a lot of photographs. Quantity does not equal quality. Sometimes less is more and, by choosing your moments and making each exposure count, you will certainly cut down on your film costs.

☐ Shooting for the Album

You have to try to keep in mind that the wedding album is a story of the day. As I photograph, I try to think about this and create images that will tell that story. I look for images that can be placed facing each other in the album. For example, a shot of the bride looking to the right would work well with a shot of the groom looking to the left.

I have seen the work of a photographer from Belgium who, I am told, used to be in the film industry. His photojournalistic coverage of weddings was among the most brilliant I have ever seen. It captured the day and was presented in a very exciting way in his album. This photographer shot only in color and took such exciting images that I talked about his album for weeks after seeing it. A well thought out, beautifully photographed wedding that tells the story of the special day should be your goal when shooting weddings – whatever your preferred style.

☐ Photography

This shot was taken with a 300mm lens at f-5.6 from a distance of about thirty feet. Tri-X 400 film was used with ambient light.

"The groom somehow is left out of most wedding coverage to a large degree."

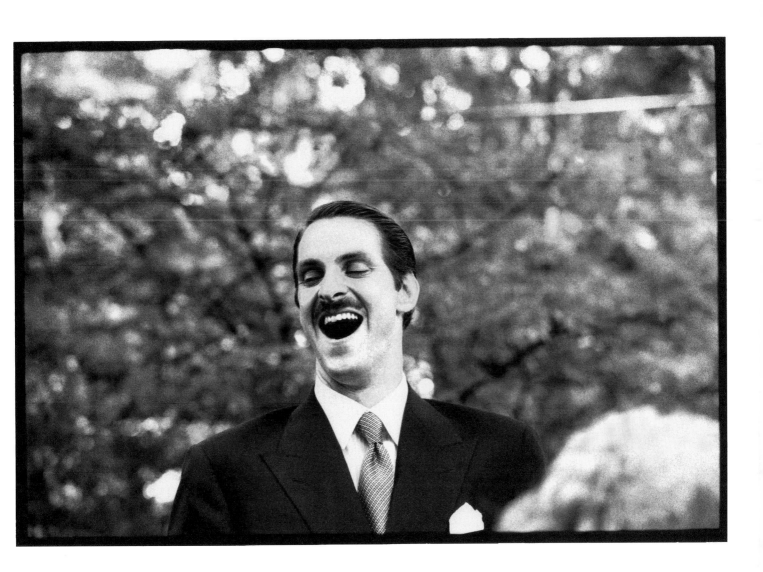

☐ The Importance of Personalities

Personalities play an important part in the wedding day – not only those of the participants, but that of the photographer, too. Obviously, we deal with many different personalities with each wedding that we attend. Some brides just want you to stay in the background and shoot, while others will play to the camera.

While personalities are important and do reflect in the final result, I sometimes look for shots that reflect the opposite of a bride or groom's personality. As an example, if I have a jovial groom – one that likes to kid around a lot – I will try to catch him in a serious moment. Recently, I photographed a wedding where the bride was extremely expressive. She was smiling, laughing, showing every emotion. I was getting great shots, yet I wanted to capture the other side of her, too. My opportunity came during the ceremony when she was next to her groom and about to exchange vows. She stood tall, looking regal and extremely proud.

The photographer has to be able to adjust his personality to the people he is with. If you are with fun people, you should be fun and smiling. If you are with people who are more stuffy and reserved, then you should act accordingly and be more serious and proper.

☐ A Warm Moment

Here, I just waited as the bride and groom talked with guests. The reward for a little patience was this wonderful image that captured the bride's beautiful smile. She looks radiant and in love – what more can a photographer ask for? Her hand on the groom's shoulder adds warmth to the image, and showing the wedding band does not hurt either.

☐ Photography

This portrait was shot with the Canon 70-200mm f-2.8 lens using Kodak TMAX 400 film. Late afternoon light was used. The shot was made at a distance of approximately 15-20 feet from the bride and groom, so as not to interfere with their conversation.

> "... we deal with many different personalities with each wedding that we attend."

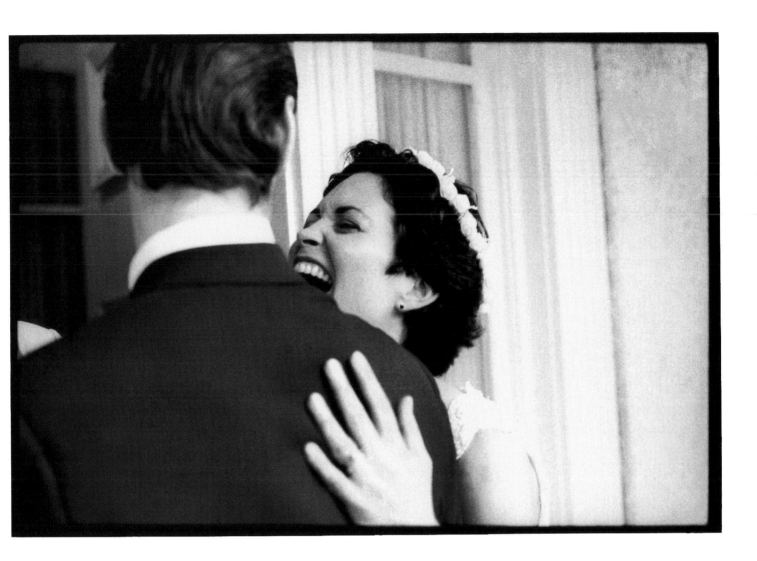

☐ A Special Request

This photograph was taken at a wedding for a friend of mine who is in the "business," so to speak. He asked me to photograph his wedding in a nontraditional manner and went about it with great zeal. As a result, this is the first wedding at which I used both color and black & white films in the 35mm format only.

We had discussed before the wedding the fact that working in this manner would not be conducive to making large size photographs, and the couple was fine with that. They wanted a smaller physical album, and a very casual look to the church and garden wedding that they were having.

☐ Capturing a Special Relationship

The bride and groom have a very special relationship. I wanted to capture the look in their eyes and the warmth that the two of them gave off. I worked a lot with the 70-200mm Canon zoom lens because it permitted me to observe without intruding. I was able to capture the wonderful expressions and looks that they kept giving each other.

☐ Photography

This, because I was working outdoors, was shot on Kodak TMAX 400 film with available light.

☐ Finding the Market

I find that this type of photography appeals to a little bit older, more sophisticated bride and groom – a couple interested in art or in a creative field. They read *Town & Country, Vanity Fair, Vogue, Martha Stewart Living*, and *W*. The customer I look for has to be savvy and not afraid to try something different. My "target" client also has to have the means to spend the extra dollars on a product such as this.

"I used both color and black & white films, in the 35mm format only."

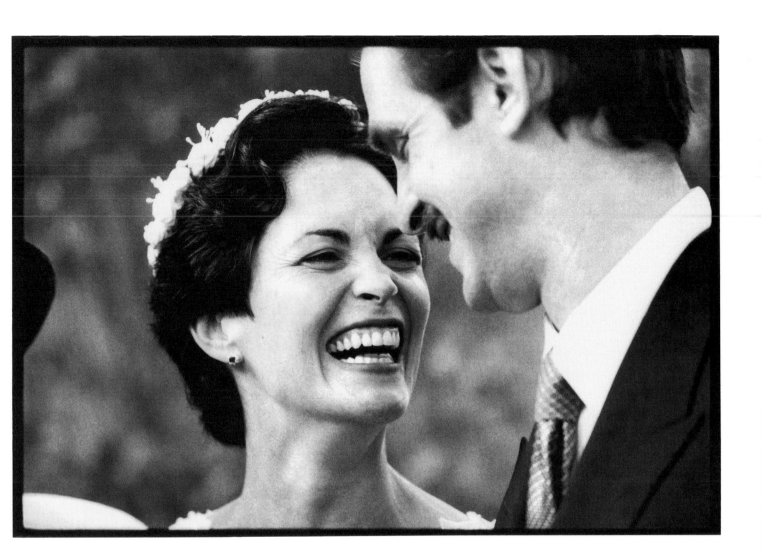

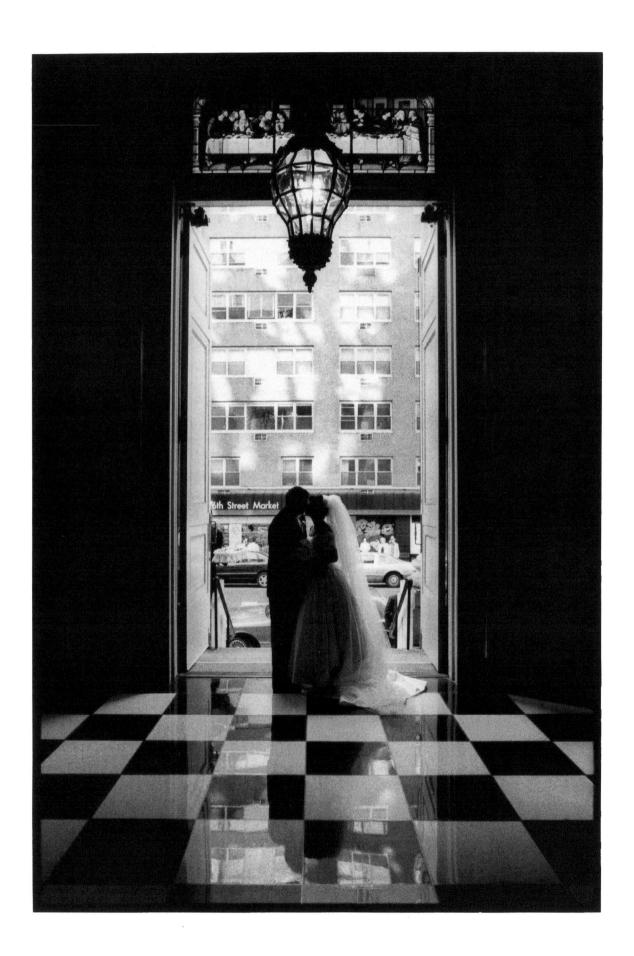

Setting up a Shot

☐ Setting up a Shot

Okay, I admit it, this was sort of posed. The bride and groom were about to exit the church, and as they were walking out, I was hoping they would kiss. I was ready for the kiss...waiting for the kiss...but it didn't happen! So, I said (fairly loudly), "Kiss!" They did, and I got this shot. It was worth breaking the rules a little for the end result.

☐ Photography

I exposed for the outdoor light so that the couple would be in silhouette. This was shot on Kodak TMAX3200 film with a Canon 28-70mm f-2.8 lens.

☐ Grain

I shoot most of my images full frame. I rarely crop and the reason is very simple. When working with these very fast films, cropping the images would only increase the grain size. This can sometimes be a good thing to do, if you like the effect that is created. However, the effect is unpredictable, and I would rather be sure of what I am getting. This is not to say that I don't experiment. It is sometimes fun to overexpose the film and have the printer print the images deep. This too will increase grain size.

"It was worth breaking the rules a little for the end result."

backlight from outside church, overexposed outside by 1 stop and printed it down in the darkroom

chandelier provides fill light on the subjects

Printing Options

☐ Prints

All our prints are made on archival paper. I use only fiber paper and never RC paper. I like the warm quality I get using fiber papers. I never tone my photographs. Rather, when I know that a client wants some sepia tone photographs, I will shoot in Kodak 400CN film and have my color lab dial in a sepia tone for me. This is very cost-effective for me as the photographer, and for the client as well.

☐ Setting and Composition

This image presented itself as the bride and groom were standing in front of the head table listening to a toast being given. I walked up behind them and was composing the image to include their heads. Then I thought that if I just included their bodies and not their heads, it would make a better photograph. I saw that the dance floor was highlighted with special lighting, and I tried to silhouette the bride and groom against the floor. I liked the effect of the flowers in the foreground and of them holding hands.

☐ Photography

This image was shot with available light on Kodak TMAX 3200 film, using a Canon 28-70mm f-2.8 lens.

"This is very cost effective for me as the photographer, and for the client as well."

spotlights
on dance floor
created a silhouette

head table

flowers lit
by pin spotlights
on the ceiling

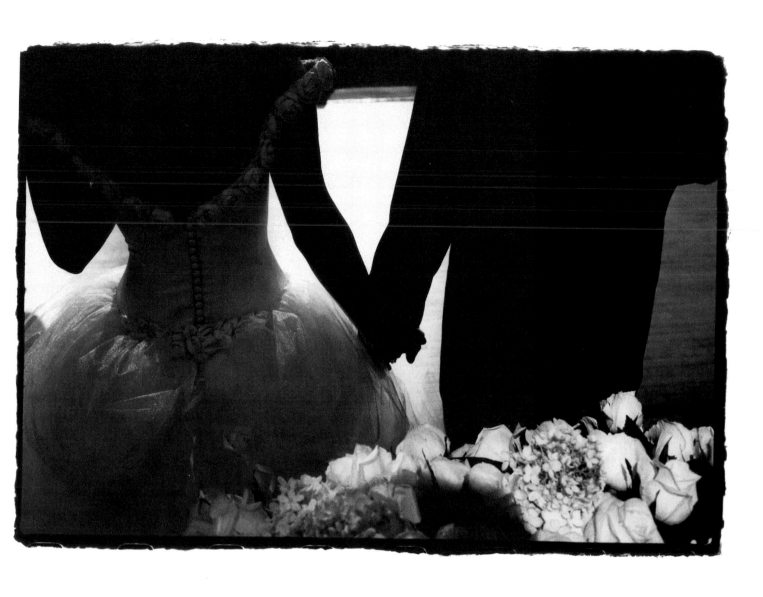

☐ End of the Ceremony

This photograph was taken at the conclusion of the ceremony itself. This is one of the best times to get great shots of the bride and groom during the wedding. All the tension and nervousness of the many months of planning and anticipation of this day are released when the bride and groom kiss at the end of the ceremony. Their expressions as they turn and come back down the aisle are always happy and excited. I usually try to shoot a series of exposures (five to six) as they walk back down the aisle. I wait to see them smile, to see the relief, then I start shooting.

☐ Presentation

Ideally, I look to get three or four of these images in a row that I can later use as a panoramic page in their album. When I print, I include all the relevant frames and even the sprocket holes on the film. It looks very cool in the album, and my customers eat it up.

☐ Photography

This image was shot with Kodak TMAX 3200 film and I used the video light from the videographer on my left to light the image.

☐ Other Special Moments

Other moments that are special during the wedding would be the first time the groom sees the bride, when the bride and groom are announced for dinner and walk into the ballroom, their first dance, and their cake cutting. Sometimes, when an emotional or funny toast is being given, I will take a shot of the speaker and then focus my camera on the reactions of the bride and groom, or the parents and grandparents. These images can sometimes be very interesting if you have the right combination of toast and expressive people.

"This is one of the best times to get great shots of the bride and groom during the wedding."

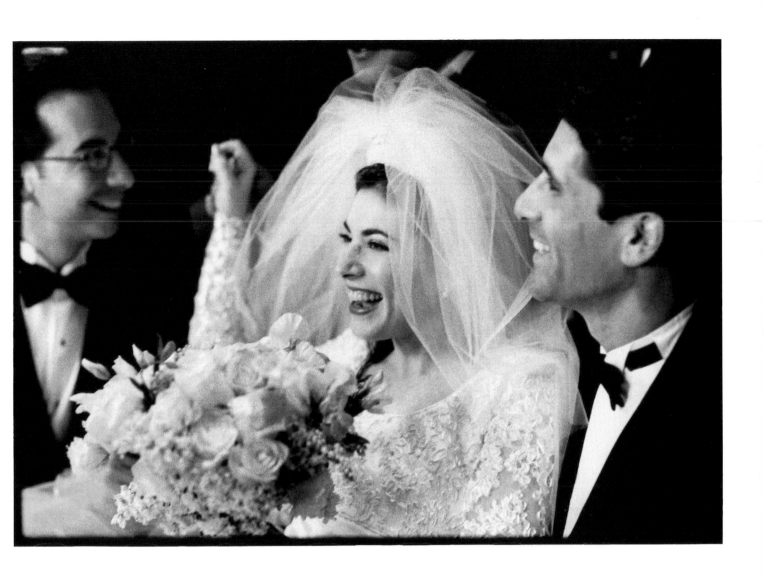

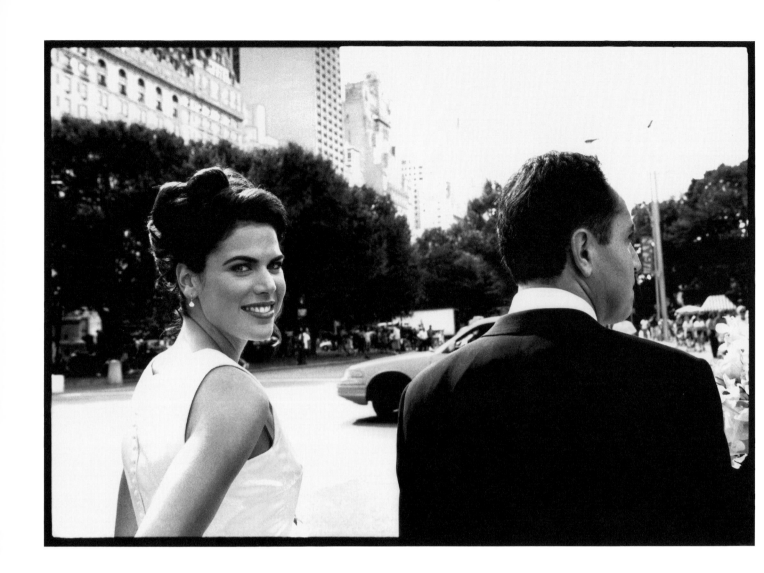

Instant Action
............

☐ Instant Action

I have this spot in Manhattan that I love to photograph around. It is the plaza around 59th Street and Fifth Avenue. I love working at the Pierre and Plaza Hotels which embrace this plaza. This small corner of the city offers endless possibilities to create photographs. This image was just a casual shot taken as we were crossing the street on our way to one of the many horse-drawn carriages that line the streets in this area. We were waiting for the traffic light to change, and the bride turned to look at me. I snapped the shot. I happened to have a wide angle zoom (17-35mm) attached to the camera and I just clicked. One always has to be ready to shoot. This type of photography requires "instant action" because no set-up time is permitted. The image was metered with the full matrix metering setting in the camera which gave me good balance between the dark and light areas of the photograph.

☐ One Photographer, Two Styles

When I work alone, I try to stay as organized as possible. I know that I need certain important photographs that my customers always purchase – family groups, bridal party, bride and groom together and individually. These I do in a traditional manner. If I see something happening out of the corner of my eye, I will pick up my 35mm and excuse myself for a few seconds to shoot what I am seeing. Most of my clients have no problem with this, because it's not like I am taking a coffee break in the middle of their portrait session; I am working for them.

☐ Candids

During down times, such as while I am waiting for a ceremony to begin, during parts of the cocktail reception, or while guests are eating dinner, I will go around and take some candid photographs. I look for good expressions or interesting situations that would make a potentially good photograph. You don't know until it happens, and you have to have a lot of patience. You can't go over and say, "Hey, lean over and give her a kiss!" This would be cheating. You have to wait, and when it happens, you have to be ready to grab the shot.

"This type of photography requires 'instant action,' no set-up time is allowed!"

☐ Working Alone

A good way to handle doing both the traditional and photojournalism work alone is to make sure you get the "bread and butter" shots first. Let's say it is the first dance. I would take my Hasselblad and shoot one or two images of the bride and groom dancing, then put down the camera and pick up the 35mm (loaded with TMAX 3200) to shoot a variety (four or five) images. I'd get one tilting the camera slightly, and one close-up of the bride's face and the back of the grooms head. Then I'd wait a few seconds, until they turn, and do a similar photograph with the groom's face and the back of the bride's head. All these should be taken with no flash, because using flash would put the bride and groom on "notice" that they are being photographed. You tend to lose the moment when that happens.

☐ Setting

This image was taken during a reception at the Plaza Hotel in Manhattan. The bride and groom had stepped away from the party, and I followed them out of the room (you never know what can happen). They stopped by this window and were having a few quiet words with each other when I took this picture. I was at least thirty feet away, and did not intrude on this private moment. I set my metering on the spot meter setting, so as not to let the bright light of the window effect the exposure and underexpose the image. I waited for the perfect expression and pushed the shutter release.

☐ Shooting at the Reception

I try to walk around the party with as little equipment as possible on my person. I do keep my equipment close by, though, and am always able to change a lens as necessary. In most cases, using zoom lenses allows you a lot of flexibility in shooting. I usually do my close-up shots with the 70-200mm lens, candids mostly with the 28-70mm lens and dancing with the 17-35mm lens. Of course, there are exceptions to all these choices, and you have to use what is best for the particular situation. I always bring plenty of film, both high speed and 400 ISO. I have never run out of film at a party. I bring twice what I think I will need – I never want to have to worry about how much I shoot.

> "...make sure you get the 'bread and butter' shots first."

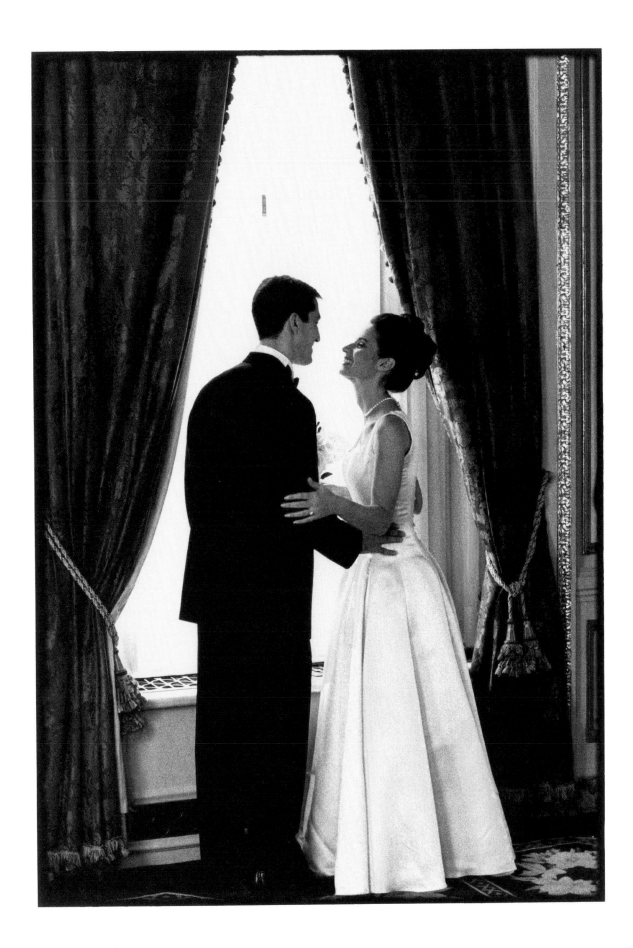

The Reception

Everything is Fair Game

☐ Portrait of a Cake

At every wedding that I attend, everything is fair game. I look for all kinds of details to photograph – flowers, jewelry, hands, eyes, details on dresses and, yes, even the wedding cake. But I don't just shoot it as the wedding cake. I need to shoot it in a different way – maybe at angle, maybe just a part of the cake, maybe a detail that no one except the bride paid any attention to. In this photograph, I liked the cake top and wanted to make it look different, even romantic. I decided to shoot the cake top from the back rather than the front. Why? Shooting it from the front is something the traditional photographer would do. I needed to have a different view, to show the wedding in different way.

These images of the "details" of a wedding are important to the story that I am telling in my black & white work. This is also an easy part of the job, because you can look for what you want to shoot and if you don't have the time right then, you can usually come back later to take the photograph.

"...a detail that no one except the bride paid any attention to."

☐ **Emotional Impact**

Here is an image of a bride and her groom that shows the love that they have between them. It was taken with a long lens so as not to be in the way. Using a wide angle lens would mean that you have to be relatively close to the couple and that, I think, would be distracting to the moment. This is a time for just these two. A third person, a photographer, has no place here. I love that her eyes are closed, I love how her arms are wrapped tightly around him. All these things add to the emotional impact of the image. As a photojournalist, you have to be ready to capture this. It may only last for a second and then disappear. If you are not quick, the moment is lost forever.

☐ **Photography**

This image was shot with a Canon 70-200mm lens on Kodak TMAX 3200. Video light provided the main light source.

☐ **Two Types of Coverage**

Black & white coverage is something we do at every wedding, but we do offer our clients two levels of coverage. One option is for a traditional photographer to shoot the entire wedding and do some black & white photographs in between everything else that he is doing. This gives the couple good, but partial, coverage of the day. I say partial, because obviously, when the bride is walking down the aisle one photographer can't shoot both with a Hasselblad and a 35mm camera. There will be pieces missing in the story, some significant and some insignificant. However, if a bride wants to have full coverage of the day in both black & white and color, then I suggest having an additional photographer come in and shoot the photojournalistic shots.

"I love how her arms are wrapped tightly around him."

Sharpness

☐ Sharpness

Not all images have to be tack sharp. Sometimes showing motion can add to the feeling the image is trying to evoke.

☐ Setting

This bride was another very expressive woman. I enjoyed photographing her wedding because she made it so easy and was so expressive. This image was taken while she was dancing during the party.

☐ Photography and Lighting

The room was quite dark, and I was trying to take advantage of the video light as my main source of illumination. The problem here, again, is that you have to have patience. You have to wait until the subject turns to the light and then shoot. Because of the strong directionality of the light, her face would be in deep shadow if I shot while she was turned away.

I shot with the 28-70mm f-2.8 lens and followed the movements of the bride. My shutter speed was around 1/15 second, and this allowed me to capture a little movement in the image. I used Kodak TMAX 3200 film, and just waited for the bride to strike a pose that I found pleasing.

"...showing motion can add to the feeling the image is trying to evoke."

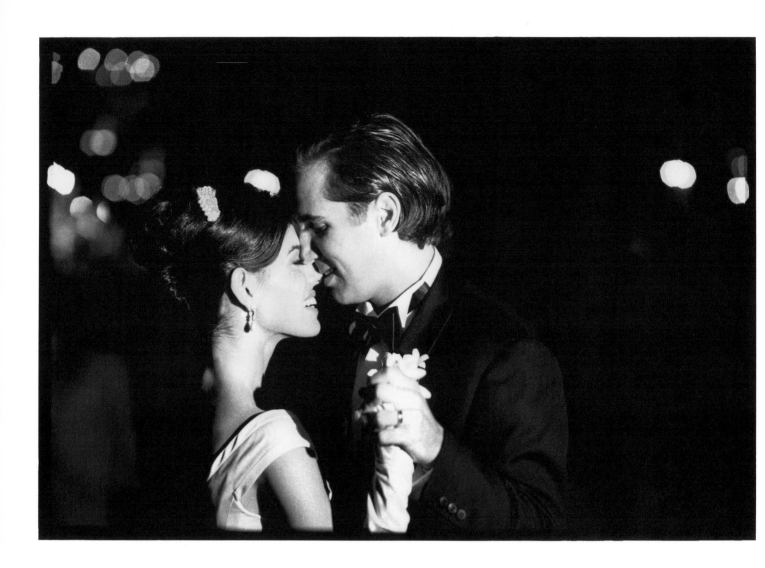

Too Much to Choose From

☐ Too Much to Choose From

This shot of a bride and groom dancing is also one of my favorites. These two are a great couple who were so easy to work with. The bride wanted everything. In our pre-wedding meeting she asked for every possible kind of photograph – traditional, photojournalistic, color, black & white, indoors and outdoors. Her album is in volumes but has mostly color images in it. This shot was not one she ordered.

This brings me to the fact that at a certain point you may be taking too many photographs at a wedding and thereby giving your couples too many to choose from. This couple decided that they wanted to take mostly color images in their album, and just a few black and white. This image was taken when I first started shooting black & white and I was really not sure how to market and sell this new format of wedding photography. I was upset at first that they did not take this image (as well as several other really great photographs) but due to the size of the order, I couldn't get terribly upset.

Now, I make sure that brides who want us to shoot black & white photographs realize that they will be expected to order a separate album, or at least put a good number of them in their color album.

☐ Setting

This was shot with the Canon 85mm f-1.2 lens on Kodak TMAX 3200 film. The light from the videographer illuminated the scene. The image was metered with the partial matrix setting on my Canon EOS-1n.

"... at a certain point you may be taking to many photographs at a wedding ..."

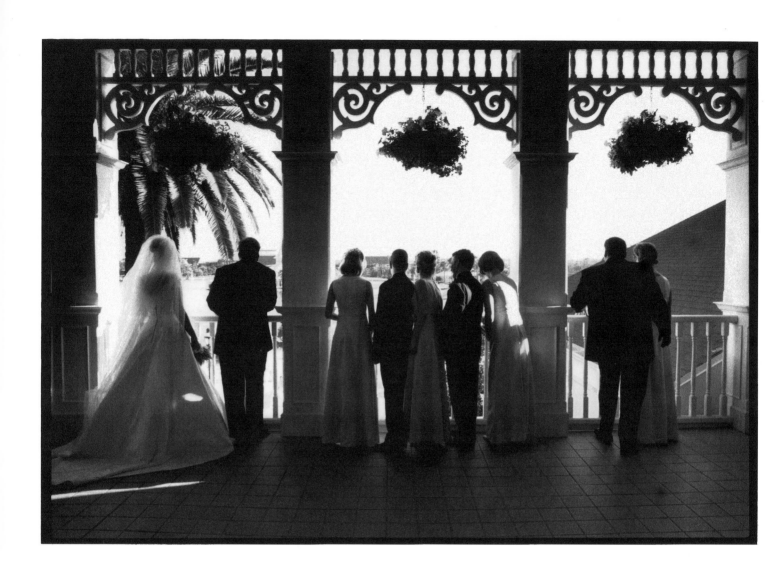

Switching Gears

☐ Setting

This was a wedding that took place at Disney World in Orlando, FL. The wedding was for a dear friend of mine who is one of the executives in charge of Disney Fairy-Tale Weddings. I wanted this to be special, and I wanted to create some really fun images.

☐ Switching Gears

I have learned how to switch gears in the middle of a wedding shoot from traditional to photojournalistic. This was the most important and hardest concept for me to master. Since I want the client to be able to order two albums from their wedding, each one has to stand on its own. Each one has to tell the story of the day from a different point of view. This means making dramatic stylistic changes from moment to moment while shooting a wedding, rather than settling into one mode of shooting for the day.

For this photograph, we were on a second floor balcony at the beautiful Grand Floridian Hotel. I actually wanted to have a shot taken of the bridal party looking over the railing at my color photographer who was standing outside the building and a floor below. I set up the shot for him and stepped back.

Then, I realized that this would also be a very cool shot for me to take in black & white. The light coming through the bride's veil was really nice, and I decided to underexpose the shot to create somewhat of a silhouette. I think the woodwork at the top of the balcony adds a lot to the shot. Light is so important to photography, and one must always look for that special light and use it to your best advantage. The beauty of black & white, of course, is that you can use any kind of light. It can be blue or green or yellow. It just doesn't matter when you are not using color film.

"This was the most important and hardest concept for me to learn."

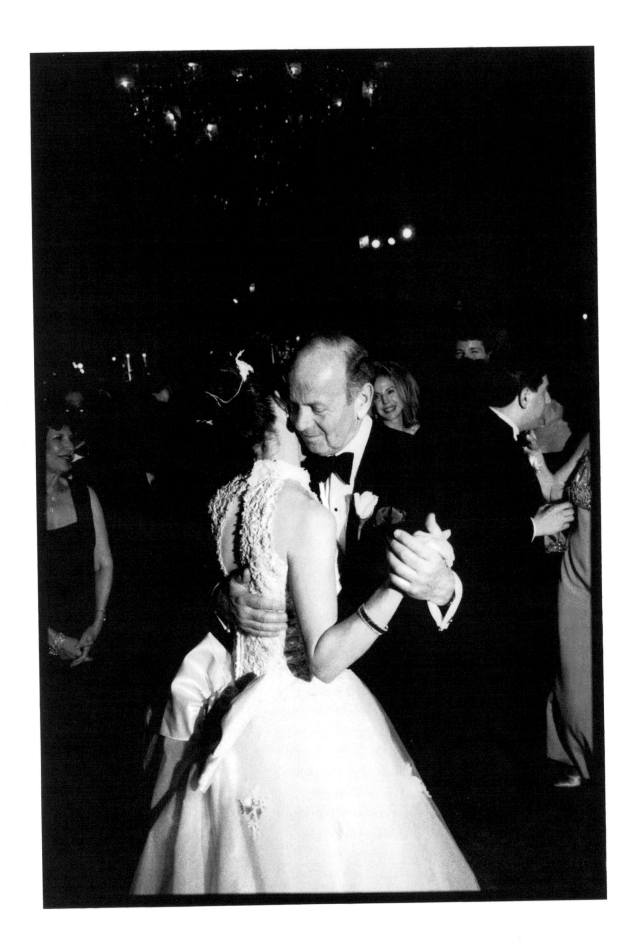

Photojournalism vs. Traditional Photography

☐ **Photojournalism vs. Traditional Photography**

Father and daughter dancing – a great time to get a great shot. I know that when my daughter gets married, they will probably have to carry me away after that dance.

Now, imagine if this image was taken by a traditional photographer. He would probably walk up to the bride and her dad and turn them around to face the camera, losing all the magic of this very special moment.

Shooting in a photojournalistic style, I look for a moment when the two are simply by themselves, just the bride and her dad. He is thinking about how she has grown into a woman too fast, and she is thinking about all the things that her "first boyfriend," the man who's been in her life since day one, means to her. The expression on the father's face tells the whole story. I also try to get a shot of the bride's face so that I can place them next to each other in the album.

☐ **Rewards**

I think my best experience photographing in a photo-journalistic manner is the satisfaction it has given me to be more creative and do something different than I have been doing for the past thrity years. My work, as far as traditional photography goes, has gotten better and more refined as the years have gone by. However, now I can go the next step and photograph all the little moments that have passed me by because the equipment that I had worked with was unable to capture them.

I get a lot of enjoyment listening to brides comment on their black & white photographs when they get the initial contact sheets. They like the behind the scenes look that I give my photographs. I am there in the middle of everything, but no one knows I am shooting because I do not use a flash. This allows me to capture natural, uncontrived images that reflect the real character of the people and the event.

"Father and daughter dancing – a great time to get a great shot."

Closing Thoughts

☐ Closing Thoughts

I would think that a person today could make a decent living just shooting weddings in a photojournalistic style. If you have a good eye and have the ability to anticipate what people might do a few seconds before they do it, then this is for you. I also feel strongly that a photographer who wants to work in this style should have some experience as a traditional wedding photographer. This gives the photojournalist some background in doing portraiture on the run, as well as a better idea of what happens on the day of the wedding.

Ultimately, I feel strongly that there is a place for both the traditional and the photojournalistic approach at a wedding. The two modes of expression certainly do not have to be mutually exclusive, and in fact, each can be used to complement the other very effectively. After all, it is hard to say to a grandmother who wants a large group portrait of her family that you are a photojournalist and therefore don't do portraiture. It is also just as hard if there is a warm, special moment going on to say that you can't capture it because you are a traditional photographer and do not have the proper equipment to shoot in that fast, candid style. Both forms of photography are important. Both are good.

☐ The Bouquet

This photograph of a bride throwing her bouquet was taken in a fairly dark ballroom. I waited, camera focused on the bride, for her to throw the bouquet. I set my lens to the widest aperture (f-2.8) to allow me to shoot at the fasted possible shutter speed. I waited till the bouquet was thrown and then waited a fraction of a second longer until it was on its way down. This is a good way to be sure you get the bouquet in the photograph. Here, the contrast between the white bouquet and the dark room help makes it highly visible.

"...there is a place for both the traditional and photojournalistic approach at a wedding."

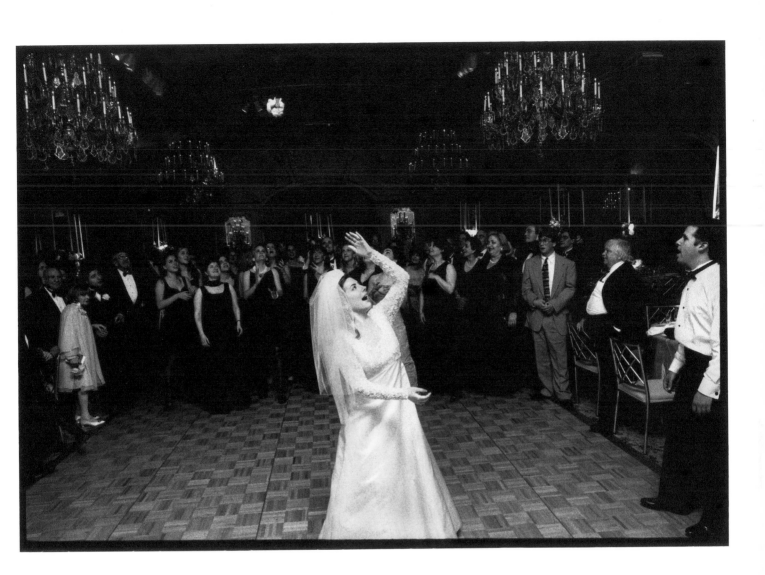

Index

A

Action, 105
Aisle, in the, 102
Albums, 4, 11, 21, 33, 47, 50, 58, 80, 92, 115
 opening and closing shots, 77
Archival materials, 100
Automobiles, 79, 82

B

Black & white photography, 21, 47, 110, 117
Bouquet, 47, 52, 64, 120
Bridal dressing room, 8, 11, 13-14, 17, 21, 39
Bridal portraits, 34-55

C

Cake cutting, 91, 102, 109
Camera selection, 42, 50
Camera tilt, 31, 52, 61
Candids, shooting, 21, 25, 105-106
Canon, 11, 13-14, 18, 21, 26, 31, 35, 45, 47, 49,
 52, 54, 57-58, 61, 63, 64, 69, 71, 75, 77,
 79-80, 82, 84, 87, 91, 94, 96, 99-100,
 110, 115,
Ceremony
 end of, 102
 photographing, 22-33
 restrictions, 31
 variations in, 25
Children, 56-72
City portraits, 73-85
Clientele, 96
Closing shots, 77
Color photography, 21
Composition, 13, 28, 36, 45, 49, 58, 100
Consultation, 8
Contact sheets, 39
 organization, 49
Creativity, 14
Cropping, 13, 99

D

Dancing, 88, 91, 102, 106, 112, 115
 father and daughter, 119

Details, shooting, 17, 33, 39, 64, 109
Depth of field, 14, 120
Dutch angles, 52

E

Environmental portraits, urban, 73-85
Evolution, 87
Exit shots, 75, 77
Exposure, 26, 31, 35, 75, 99, 117

F

Film
 grain, 26, 45, 50, 99
 Kodak TMAX400CN, 21, 39, 42, 69, 100
 limitations, 64
 organization, 49
 usage, 18, 47, 106
Flash, 21, 106
Fred Marcus Photography, 5-6

G

Garter, 39
Getting started, 36, 52, 61, 120
Gown, 8, 42, 47, 54
Groom, 18, 92

H

Hasselblad, 21, 42, 58, 106, 110

K

Kissing, 31, 82, 99
Kodak, *see film*

L

Large weddings, 40
Leica, 36, 39, 58, 66, 72
Lens flare, 23
Lens selection, 26, 28, 54, 79, 96, 106, 110
Lighting, 8, 11, 13, 17-18, 25-26, 31, 35-36, 45, 50,
 61, 71, 99, 112
Location photography, urban, 73-85

M

Medium format, 42, 50
Metering, 31, 35, 42, 47, 66. 75, 82, 88, 106
Minolta, 42
Mirrors, 14
Mobility, 50
Motor drive, 21
Movement, 112, 120
Multiple images, 11, 71

N

Negatives, organization, 49

O

Opening shots, 77, 82
Organization, 49, 105
Outdoor weddings, 23, 26

P

Panoramic pages, 11, 71, 102
Personality, capturing, 40, 94
Portrait photography, 21
Posing, 40, 45
Preparation, 8, 106
Presenting images, 49
Pricing, 66, 79
Printing, 50, 69, 80, 99, 100
 archival paper, 100
Processing, 45
Proofing, 39, 69

R

Reception, 108-121
Restrictions during ceremony, 31
Rewards, 119
Ring exchange, 23, 31

S

Sales area, 6, 66
Sales, boosting, 21, 33, 47, 50, 58, 82, 120
Sequential images, 11, 71
Sharpness, 112
Shyness, 69
Silhouettes, 99, 117
Spontaneity, 87
Storytelling, 49, 91
Switching gears, 52, 105, 117

T

Test roll, 45
Tilt, camera, 31
Tinting, 42, 69, 100
Toast, 102

U

Urban portraits, 73-85

V

Video lighting, 31, 35, 102, 115

W

Wedding photography, traditional, 4, 40, 54, 75, 110, 120
Working with clients, 8, 40, 94

Z

Zoom lens, 28, 105-106

Other Books from
Amherst Media, Inc.

Infrared Photography Handbook

Laurie White

Covers b&w infrared photography: focus, lenses, film loading, film speed rating, heat sensitivity, batch testing, paper stocks, and filters. Photos illustrate IR film in portrait, landscape, and architectural photography. $29.95 list, 8½x11, 104p, 50 b&w photos, charts & diagrams, order no. 1419.

Wedding Photography: Creative Techniques for Lighting and Posing

Rick Ferro

Creative techniques for lighting and posing wedding portraits that will set your work apart from the competition. Covers every phase of wedding photography. $29.95 list, 8½x11, 128p, b&w and color photos, index, order no. 1649.

Into Your Darkroom Step-by-Step

Dennis P. Curtin

This is the ideal beginning darkroom guide. Easy to follow and fully illustrated each step of the way. Includes information on: the equipment you'll need, set-up, making proof sheets and much more! $17.95 list, 8½x11, 90p, hundreds of photos, order no. 1093.

Professional Secrets of Advertising Photography

Paul Markow

No-nonsense information for those interested in the business of advertising photography. Includes: how to catch the attention of art directors, make the best bid, and produce the high-quality images your clients demand. $29.95 list, 8½x11, 128p, 80 photos, index, order no. 1638.

Outdoor and Location Portrait Photography

Jeff Smith

Learn how to work with natural light, select locations, and make clients look their best. Step-by-step discussions and helpful illustrations teach you the techniques you need to shoot outdoor portraits like a pro! $29.95 list, 8½x11, 128p, b&w and color photos, index, order no. 1632.

How to Shoot and Sell Sports Photography

David Arndt

A step-by-step guide for amateur photographers, photojournalism students and journalists seeking to develop the skills and knowledge necessary for success in the demanding field of sports photography. $29.95 list, 8½x11, 120p, 111 photos, index, order no. 1631.

Freelance Photographer's Handbook

Cliff & Nancy Hollenbeck

Whether you want to be a freelance photographer or are looking for tips to improve your current freelance business, this volume is packed with ideas for creating and maintaining a successful freelance business. $29.95 list, 8½x11, 107p, 100 b&w and color photos, index, glossary, order no. 1633.

How to Operate a Successful Photo Portrait Studio

John Giolas

Combines photographic techniques with practical business information to create a complete guide book for anyone interested in developing a portrait photography business (or improving an existing business). $29.95 list, 8½x11, 120p, 120 photos, index, order no. 1579.

Infrared Landscape Photography

Todd Damiano

Landscapes shot with infrared can become breathtaking and ghostly images. The author analyzes over fifty of his most compelling photographs to teach you the techniques you need to capture landscapes with infrared. $29.95 list, 8½x11, 120p, b&w photos, index, order no. 1636.

Fashion Model Photography

Billy Pegram

For the photographer interested in shooting commercial model assignments, or working with models to create portfolios. Includes techniques for dramatic composition, posing, selection of clothing, and more! $29.95 list, 8½x11, 120p, 58 photos, index, order no. 1640.

Computer Photography Handbook

Rob Sheppard

Learn to make the most of your photographs using computer technology! From creating images with digital cameras, to scanning prints and negatives, to manipulating images, you'll learn all the basics of digital imaging. $29.95 list, 8½x11, 128p, 150+ photos, index, order no. 1560.

Achieving the Ultimate Image

Ernst Wildi

Ernst Wildi teaches the techniques required to take world class, technically flawless photos. Features: exposure, metering, the Zone System, composition, evaluating an image, and more! $29.95 list, 8½x11, 128p, 120 b&w and color photos, index, order no. 1628.

Black & White Portrait Photography

Helen Boursier

Make money with b&w portrait photography. Learn from top b&w shooters! Studio and location techniques, with tips on preparing your subjects, selecting settings and wardrobe, lab techniques, and more! $29.95 list, 8½x11, 128p, 130+ photos, index, order no. 1626

Stock Photography

Ulrike Welsh

This book provides an inside look at the business of stock photography. Explore photographic techniques and business methods that will lead to success shooting stock photos — creating both excellent images and business opportunities. $29.95 list, 8½x11, 120p, 58 photos, index, order no. 1634.

Profitable Portrait Photography

Roger Berg

A step-by-step guide to making money in portrait photography. Combines information on portrait photography with detailed business plans to form a comprehensive manual for starting or improving your business. $29.95 list, 8l/2x11, 104p, 100 photos, index, order no. 1570

Professional Secrets for Photographing Children

Douglas Allen Box

Covers every aspect of photographing children on location and in the studio. Prepare children and parents for the shoot, select the right clothes capture a child's personality, and shoot story book themes. $29.95 list, 8½x11, 128p, 74 photos, index, order no. 1635.

Handcoloring Photographs Step-by-Step

Sandra Laird & Carey Chambers

Learn to handcolor photographs step-by-step with the new standard in handcoloring reference books. Covers a variety of coloring media and techniques with plenty of colorful photographic examples. $29.95 list, 8½x11, 112p, 100+ color and b&w photos, order no. 1543.

Special Effects Photography Handbook

Elinor Stecker Orel

Create magic on film with special effects! Little or no additional equipment required, use things you probably have around the house. Step-by-step instructions guide you through each effect. $29.95 list, 8½x11, 112p, 80+ color and b&w photos, index, glossary, order no. 1614.

McBroom's Camera Bluebook

Mike McBroom

Comprehensive and fully illustrated, with price information on: 35mm, medium & large format cameras, exposure meters, strobes and accessories. Pricing info based on equipment condition. A must for any camera buyer, dealer, or collector! $29.95 list, 8½x11, 224p, 75+ photos, order no. 1263.

Fine Art Portrait Photography

Oscar Lozoya

The author examines a selection of his best photographs, and provides detailed technical information about how he created each. Lighting diagrams accompany each photograph. $29.95 list, 8½x11, 128p, 58 photos, index, order no. 1630.

Black & White Nude Photography

Stan Trampe

This book teaches the essentials for beginning fine art nude photography. Includes info on finding your first model, selecting equipment, and scenarios of a typical shoot, plus more! Includes 60 photos taken with b&w and infrared films. $24.95 list, 8½x11, 112p, index, order no. 1592.

Family Portrait Photography

Helen Boursier

Learn from professionals how to operate a successful portrait studio. Includes: marketing family portraits, advertising, working with clients, posing, lighting, and selection of equipment. Includes images from a variety of top portrait shooters. $29.95 list, 8½x11, 120p, 123 photos, index, order no. 1629.

The Art of Portrait Photography

Michael Grecco

Michael Grecco reveals the secrets behind his dramatic portraits which have appeared in magazines such as *Rolling Stone* and *Entertainment Weekly*. Includes: lighting, posing, creative development, and more! $29.95 list, 8½x11, 128p, order no. 1651.

Essential Skills for Nature Photography

Cub Kahn

Learn all the skills you need to capture landscapes, animals, flowers and the entire natural world on film. Includes: selecting equipment, choosing locations, evaluating compositions, filters, and much more! $29.95 list, 8½x11, 128p, order no. 1652.

Black & White Landscape Photography

John Collett and David Collett

Master the art of b&w landscape photography. Includes: selecting equipment (cameras, lenses, filters, etc.) for landscape photography, shooting in the field, using the Zone System, and printing your images for professional results. $29.95 list, 8½x11, 128p, order no. 1654.

Photo Retouching with Adobe Photoshop

Gwen Lute

Designed for photographers, this manual teaches every phase of the process, from scanning to final output. Learn to restore damaged photos, correct imperfections, create realistic composite images and correct for dazzling color. $29.95 list, 8½x11, 128p, order no. 1660.

Creative Lighting Techniques for Studio Photographers

Dave Montizambert

Master studio lighting and gain complete creative control over your images. Whether you are shooting portraits, cars, table-top or any other subject, Dave Montizambert teaches you the skills you need to confidently create with light. $29.95 list, 8½x11, 128p, order] no. 1666.

Fine Art Children's Photography

Doris Carol Doyle

Learn to create fine art portraits of children in black & white. Included is information on: posing, lighting for studio portraits, shooting on location, clothing selection, working with kids and parents, and much more! $29.95 list, 8½x11, 128p, order no. 1668.

Infrared Portrait Photography

Richard Beitzel

Discover the unique beauty of infrared portraits, and learn to create them yourself. Included is information on: shooting with infrared, selecting subjects and settings, filtration, lighting, and much more! $29.95 list, 8½x11, 128p, order no. 1669.

Black & White Photography for 35mm

Richard Mizdal

A guide to shooting and darkroom techniques! Perfect for beginning or intermediate photo-graphers who wants to improve their skills. Features helpful illustrations and exercises to make every concept clear and easy to follow. $29.95 list, 8½x11, 128p, order no. 1670.

Amherst Media's Customer Registration Form

Please fill out this sheet and send or fax to receive free information about future publications from Amherst Media.

Customer Information

Date

Name

Street or Box #

City State

Zip Code

Phone () Fax ()

Optional Information

I bought *Wedding Photojournalism* because

I found these topics to be most useful

I purchased the book from

City State

I would like to see more books about

I purchase ____ books per year

Additional comments

FAX to: 1-800-622-3298

Name_____
Address_____
City_____State_____
Zip_____ — _____

Amherst Media, Inc.

PO Box 586

Buffalo, NY 14226